Drawing **Flowers**

Margaret Eggleton

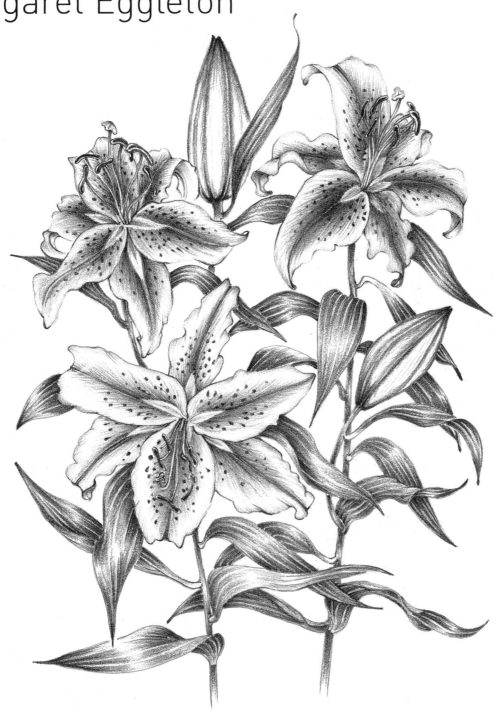

SEARCH PRESS

First published in Great Britain 2012

Search Press Limited
Wellwood, North Farm Road,
Tunbridge Wells, Kent TN2 3DR

ISBN: 978-1-84448-724-0

The Publishers and author can accept
no responsibility for any consequences
arising from the information, advice or
instructions given in this publication.

Suppliers
If you have difficulty in obtaining
any of the materials and equipment
mentioned in this book, then please
visit the Search Press website for
details of suppliers:
www.searchpress.com

Printed in Malaysia

Acknowledgements

First of all I would like to thank my editor, Sophie Kersey
for her help, encouragement and patience during the
making of this book and also Roz Dace at Search Press.
Without them this book would never have happened.
I am also very grateful to Sam at 'Greensleeves' florists
for her endless supply of exotic and unusual flowers, as
well as her expert knowledge of worldwide floristry. My
various groups of art students have been helpful with
suggestions and comments as the book has progressed,
and have acted as guinea pigs on several occasions.
Last of all I would like to thank all my family for their
support and understanding.

Front cover
Passion Flower and Hibiscus in Graphite
26 x 37cm (10¼ x 14½in)

*The graceful arch of the passion flower, with its bud and fruit
is a perfect partner for the hibiscus. Both are found in many
countries of the world. The step by step project is on page 70.*

Page 1
Variegated Sunflowers
56 x 37cm (22 x 14½in)

*Graphite pencils and sticks on pale cream watercolour paper.
I was delighted to find this bunch of sunflowers with so
many different shapes and textures to draw. They were so
big that I had to use my largest vase to put them in. It was
also satisfying to decipher the reflections on the ceramic
vase. Placing a flower on the table next to the vase gives
the drawing more interest in the lower half of the picture,
especially if it is covering the lower ellipse of the vase.*

Page 2
Dark Burgundy Carnations in Graphite
12 x 28cm (4¾ x 11in)

*The petals of these carnations, with their intensely dark upper
surface and pale reverse made them a joy to draw in graphite.*

Page 3
Stargazer Lilies in Graphite
18 x 26cm (7 x 10¼in)

*The pale petals with their spots contrasted beautifully with
the shiny striped leaves. The step by step project is on page 52.*

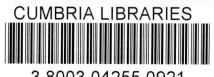
Drawing Flowers

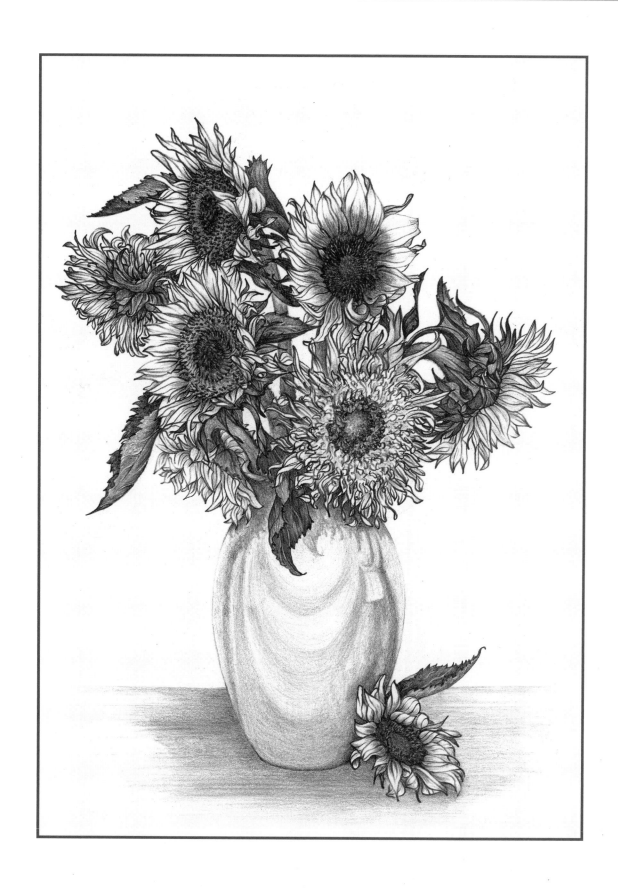

Dedication

To my husband, Stuart.

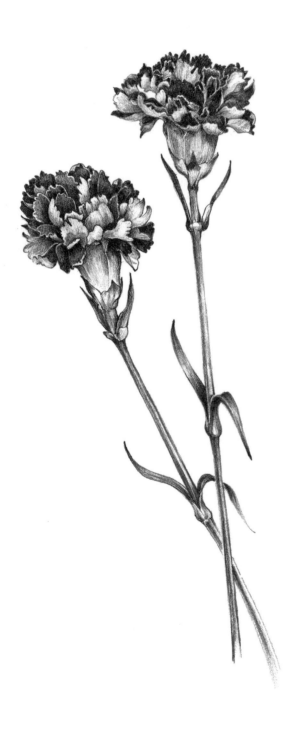

Contents

Introduction

Drawing has always been a passion of mine. My mother tells me that I was drawing as soon as I could hold a pencil and I certainly enjoyed the praise and encouragement of all the family. Art was my favourite subject at school. Flowers have also been a part of my life for as long as I can remember, and as a child I loved seeing them grow from the seeds I had sown in my own corner of the garden. It seems natural for me to draw flowers to express how I feel about the shapes and tones in a way that cannot be done with words.

As a qualified school teacher, I naturally enjoy teaching many forms of art. I teach, demonstrate and critique at several different art groups and get much satisfaction from their appreciation and success. I am always trying to find new ways to help them perfect their work and have been writing and illustrating step by step demonstration sheets for my students for over twenty years. I believe good drawing skills are fundamental for all successful artwork and that techniques can be taught and learnt with practice, patience and perseverance.

Being able to draw is like being able to see. Once techniques have been mastered, you can express and share how you feel about the subject that originally inspired you. This is unique for each person. Throughout this book I have constantly extolled the need to look at the flower being drawn more than the drawing on the paper. The flowers are the inspiration for the drawing and your eyes caress the shapes as your hand obediently translates them on to paper. I cannot stress too much the value of drawing from life, whatever the subject. In this way you can see the flower in three dimensions and can turn it round or just move your head slightly to understand it better. Buds, flowers and leaves can also be added to your composition more easily than if you are working from a photograph, even if it is your own.

Keeping a sketchbook is fundamental to improving observational and drawing skills. Life constantly surprises me with images that cry out to be recorded at the moment of inspiration. If my sketchbook and drawing materials are in my pocket or bag, I need never waste time waiting for a meal or flight. When I am on holiday, sketching adds to the pleasure and relaxation as well as giving me a record of the places I have visited. One never really sees something properly until one starts to draw it. Sketches are a useful reference for my studio work.

Just as a room with flowers in it is transformed, a picture with flowers draws attention to itself, whether it is a detailed botanical drawing, a strong drawing with acrylic ink, or a loose representation in pastel or Conté. Sometimes the most successful drawings are happy accidents. Trying different media can help your drawing skills and you may find something that really suits your style. I hope you find much in this book that is helpful and enjoyable for many years to come.

Opposite
Tree Peony
This drawing is done in acrylic ink with a dip pen. The tree peony is growing in my garden and has many more flowers this year than ever before. I love the flamboyant shapes of the flowers and the dramatic spread of the leaves.

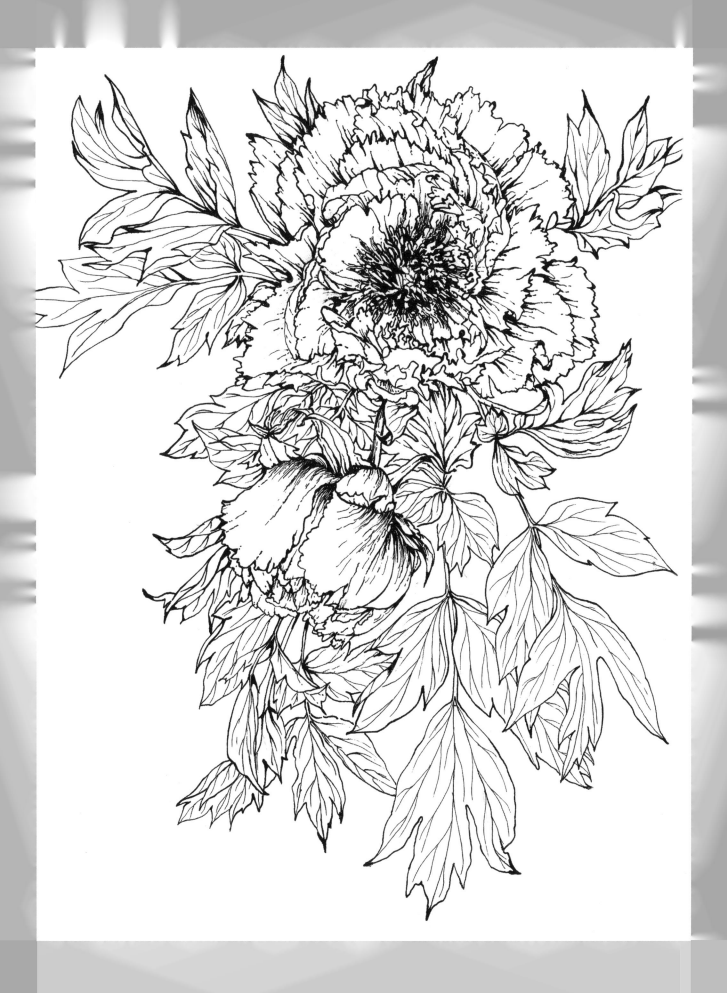

The history of flower drawing

This illuminated letter 'M' was done in artist's pen and graphite stick.

People have been drawing since prehistoric times and evidence of this is still to be seen in the Lascaux Caves in France, where the images are mostly of animals and hunting with occasional bushes at the side.

Flowers and leaves have been used in Chinese drawings and paintings for over 2,000 years. Chinese artists would use a stiff brush made with wolf's or leopard's hair, for calligraphy and outline drawing. They would then use a soft brush made with goat's or sheep's hair for leaves and petals. Inks were used that were moistened from solid blocks. Later the styles and ideas were incorporated into drawings in other countries. These flower drawings had developed from calligraphy and were either in an outline drawing style or with a spontaneous style in a few linear strokes showing freedom and movement.

The earliest surviving manuscripts that contain flower drawings were made by monks in monasteries dating back to AD400. In medieval times, monastic scribes were illuminating the capital letters of the scriptures that they were copying. They portrayed images of flowers and plants on vellum or parchment. They used ink and watercolour and would often embellish them with pure gold leaf.

By the 14th–18th centuries, draughtsmen were using paper as well as parchment for their flower images in red chalk, charcoal and pen and ink. Artists such as Leonardo da Vinci, Durer and Watteau incorporated flowers and plants around their figure drawings.

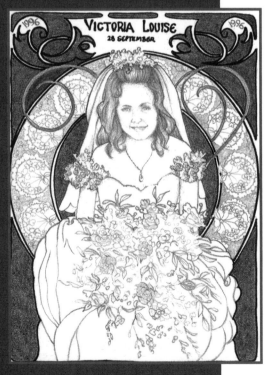

Victoria Louise in the style of Mucha, using artist's pen and graphite stick.

An orchid in Chinese brush drawing, using acrylic ink, reed pen and water pen.

The Art Nouveau movement in the 19th and 20th centuries was the first European style to stop copying past ideas from the history of art. Instead, artists took their inspiration from the natural world of plants, birds, animals and flowers. There are two main styles of Art Nouveau, one using mainly curved lines and the other using mainly straight lines. Alphonse Mucha was one of those who used curved lines, arches and even complete circles. If he did use a straight line to surround his work, he always curved it round the corner before joining another line. Born in Moravia, he said that drawing had been his main hobby since childhood. All his work shows a very linear, fluid style with a combination of realistic effects and a strong sense of pattern. Although his main subject was the human female form, he used many different floral effects to adorn and decorate them.

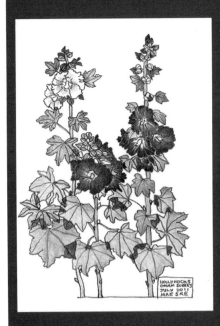

Hollyhocks in the style of Charles Rennie Mackintosh.

The other Art Nouveau style was using straight lines for more austere linear work, like that of Charles Rennie Mackintosh. Working in Glasgow and London, he drew many designs in pencil, often getting inspiration from flower designs for his furniture, jewellery and stained glass windows. He enjoyed drawing flowers in pencil in a more natural, botanical way as a leisure activity when on holiday with his wife at Walberswick in Suffolk. After painting the drawings in watercolour, he would draw a 'cartouche' at the bottom with the flower name, the place where he drew it, the date and the initials of those who were present at the time, which was usually just himself and his wife, Margaret.

Another 19th Century artist who is known to have done more than 1,000 incredible drawings, as well as many paintings in his short life, is Vincent Van Gogh. In a letter to his brother Theo, he said that drawing was a necessary task for an artist, to build a foundation. He drew in pencil, red and black chalk, reed pen, ink and charcoal. He would draw before and after completing a painting, often illustrating his many letters to his brother. He said he could capture light and images more quickly by drawing than painting. His style of drawing was similar to his painting, with quick, confident, broad strokes showing life and movement. Flowers were a recurring subject and he did many paintings and drawings of the sunflowers that grew in the nearby fields.

Flowers are so inspiring, with their varied and interesting shapes, vivid colours and sensational perfumes that they will no doubt continue to be a favourite subject for many more artists for years to come.

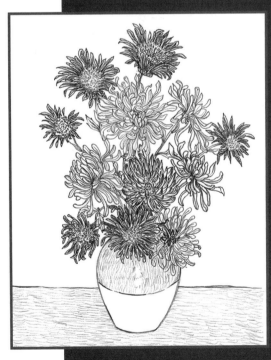

Chrysanthemums in the style of Van Gogh, using 6B graphite and 4B water soluble graphite stick.

Materials

Drawing can be done with anything that makes a mark. However, most people prefer to use pencils, which are easily available, dry and can be erased if necessary. Ink pens are also readily obtained, dry quickly and give a strong dark line. Acrylic ink and a dip pen give a satisfying result with varying width of lines, but they take longer to dry. Crayons of different substances are popular for a loose sketch.

GRAPHITE PENCILS

Graphite pencils are made from baked graphite and clay. Hard pencils (ranging from H–8H) have more clay than graphite and are mostly used for technical and architectural drawings that require a firm, pale, accurate line. Soft pencils (ranging from B–9B) have more graphite in them, with 8B having the highest ratio of graphite to clay and giving the blackest line. I usually use an HB pencil (neither hard nor soft) for the initial outline of a drawing.

After drawing the outline, I use soft pencils for flower drawings. I mark the ends of my pencils with blobs of varnish or acrylic paint: B pencils having one blob, 2B having two blobs and so on. This way it is easy to identify and pick up a succession of pencils, each softer than the last, without losing concentration on your drawing. I always lay them out in the correct order before I start. My HB pencils have no blobs and I place them on the other side of my paper, making sure they are sharpened to a good point.

Graphite pencils need to be treated carefully, and must not be jolted or dropped. The leads could break inside the pencil before you have sharpened them. Treat them like fresh eggs!

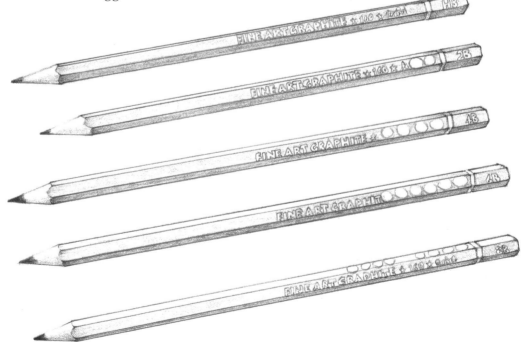

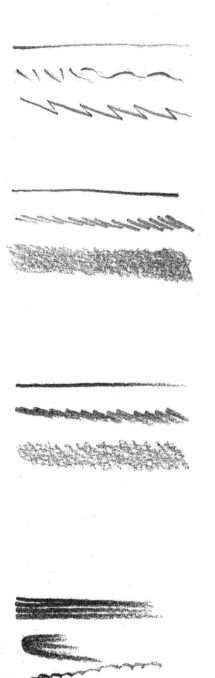

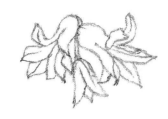

The HB grade pencil is used mainly for the initial outline drawing. It is also useful for faint vein lines on flowers and leaves.

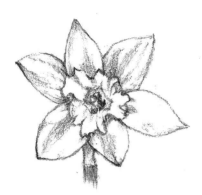

The 2B pencil is useful for gentle shading and can also be used, sharpened to a fine point, to give a stronger thin line over the HB outline.

The tones of the shading can be emphasised using the 4B pencil, especially near the centre of a flower. Varying the pressure can create different tones and add interest.

The 6B pencil can further emphasise the extremities and add strong, confident marks to create excitement in the drawing.

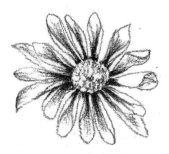

With the 8B graphite pencil, very black marks can be made in strategic points to give depth and draw the viewer's eye to the focal point.

ACRYLIC INK AND DIP PEN

Acrylic inks can be used with a dip pen to create thick and thin lines. This variation of line creates a more interesting drawing. Acrylic ink is thick and flows freely, which sometimes causes blobs after the pen has just been dipped in. I regard this as fortunate, if it does not happen too often, as it adds to the variety of marks, is raised up from the surface of the paper and still shines when dry. If you use acrylic ink and dip pen without a preliminary drawing, it creates spontaneity which not only gives a livelier drawing but is also more satisfying. However, as it takes some time to dry, depending on thickness, it is easily smudged, and is almost impossible to erase. Splashes and drips sometimes happen but can be avoided with care. Indian ink and drawing ink can also be used effectively with a dip pen for drawing flowers.

A pansy drawn with acrylic ink and a dip pen.

A peony drawn with acrylic ink and a dip pen.

ARTIST'S PENS

These pens are readily available in art shops. They come in different sizes and various brands. They are sometimes called technical pens or drawing pens and are generally alcohol or pigment based. It is best to start with permanent, light-fast pens in a medium size: 03, 05, or 07. Achieving variety of line is more difficult using these pens than if you use a dip pen and liquid ink. However, on the plus side, the ink in these pens dries almost instantly and so it is not easily smudged and is therefore a good way to start drawing in ink. They are also easier to carry around and use in sketchbooks and on holiday.

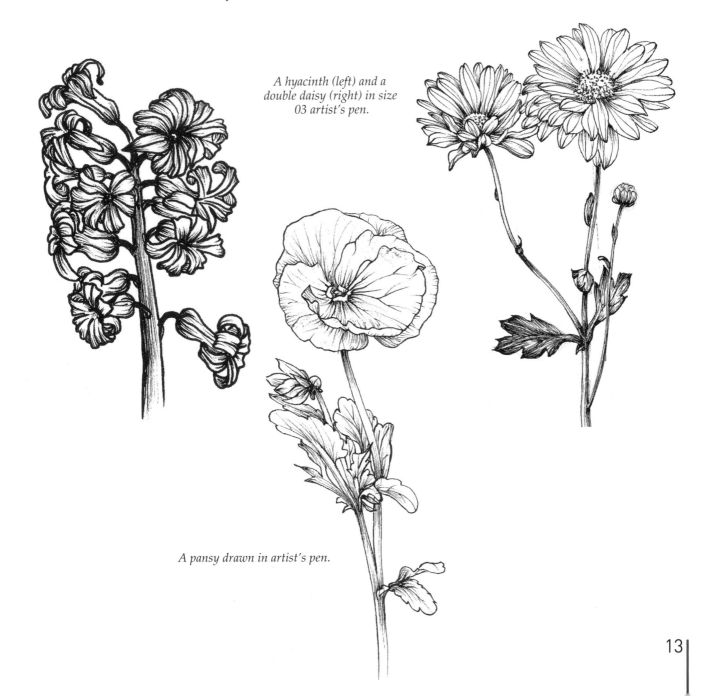

A hyacinth (left) and a double daisy (right) in size 03 artist's pen.

A pansy drawn in artist's pen.

13

CONTÉ CRAYONS

At the end of the 18th Century, Nicolas-Jacques Conté discovered a unique mixture of red, white or black chalk with clay, that made drawing sticks (carrés) that were firmer than soft pastel. They are capable of detailed, delicate work such as that done by Antoine Watteau, as well as broader and looser strokes. They can be blended by using a paper stump or cotton bud. The square shape of the carré crayon makes it possible to use smaller or larger pieces on their sides to make an infinite variety of freely executed, broad marks. Firmer pressure gives a stronger density of colour. Artists today have the choice of Conté crayons or pencils.

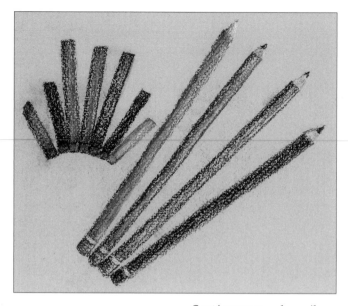

Conté crayons and pencils, drawn on pastel paper.

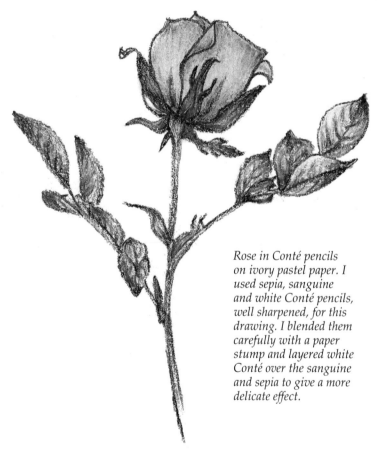

Rose in Conté pencils on ivory pastel paper. I used sepia, sanguine and white Conté pencils, well sharpened, for this drawing. I blended them carefully with a paper stump and layered white Conté over the sanguine and sepia to give a more delicate effect.

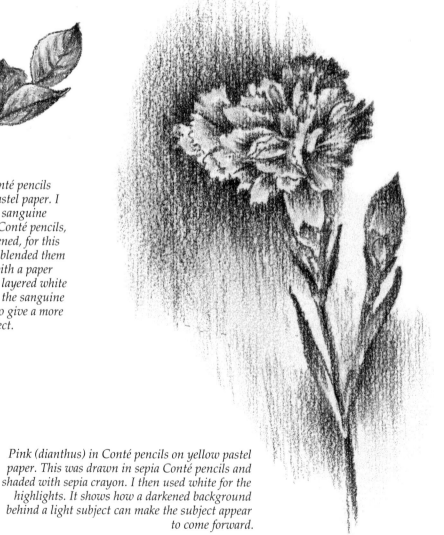

Pink (dianthus) in Conté pencils on yellow pastel paper. This was drawn in sepia Conté pencils and shaded with sepia crayon. I then used white for the highlights. It shows how a darkened background behind a light subject can make the subject appear to come forward.

14

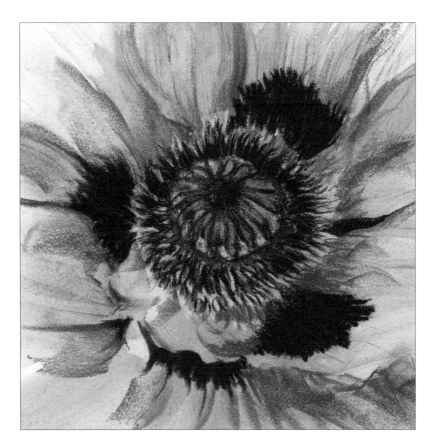

Oriental poppy in Conté on white Saunders Waterford Not watercolour paper. I drew the basic shapes in pencil first, then used a damp sponge dipped in sanguine shavings to shade the petals before using a sanguine Conté crayon on its side on the still damp paper for deeper tones. Next I drew the white end of the corona before drawing in the black blotches and many corona filaments with black Conté crayons. The central seed head was drawn in sepia and white.

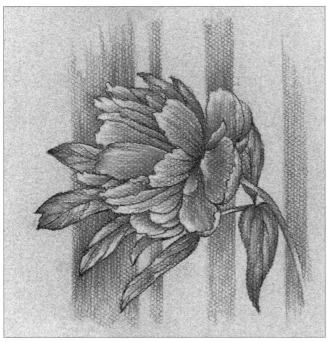

Peony in Conté pencil and crayon on textured pastel paper. I drew this with a black Conté pencil, then shaded it with sanguine Conté crayon and highlighted with white. The background is dark behind the lighter parts of the flower and lighter behind the dark parts.

Osteospermum in a cup basket, on beige pastel paper. I drew the centres of the flowers first in sanguine, then the petals round them in white. I drew the leaves with sanguine and sepia crayons and the basket in white crayon. I filled in the soil with black crayon and added the basket shading in sepia. Finally I shaded the table lightly with sanguine and sepia crayons on their sides.

SURFACES

It is important to choose the right surface for each drawing. The thicker and better quality the paper used, the more satisfied you will be with your final drawing. If the paper is not in a pad or block, it is best to dry mount it to a board with masking tape.

I like to have a firm A4 sketchbook with good quality cartridge paper for holiday and outdoor sketches in pen or pencil, but I also take a pad or block of watercolour paper in wide panorama format, if I know I have more time, in case I want to add a light wash to drawings. Watercolour paper is also essential if you are using a water pen, as cartridge paper will cockle when wet and spoil the drawing. A smaller sketchbook is also handy to carry in your bag or pocket and useful for quick sketches and for planning layouts.

For studio drawings from life, or occasionally from my own photographs, I use A3 or A4 300gsm (140lb) Hot Pressed watercolour paper. Most of my drawings are on this paper. Cotton based, acid free paper will not fade or discolour in time. HP (Hot Pressed) paper is smooth, Not (Cold Pressed) paper is medium textured and Rough paper, though rarely used for drawing, provides some interesting effects.

Tinted watercolour or pastel paper is good for Conté and pastel drawings, as it provides the middle ground that can set off white for highlights and a base for darker line and tone. Also, the rougher texture of the paper provides a 'tooth' for the pastel or Conté to adhere to.

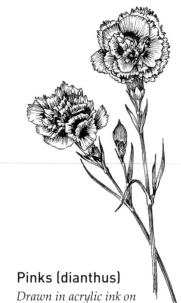

Pinks (dianthus)
Drawn in acrylic ink on 300gsm (140lb) Hot Pressed watercolour paper.

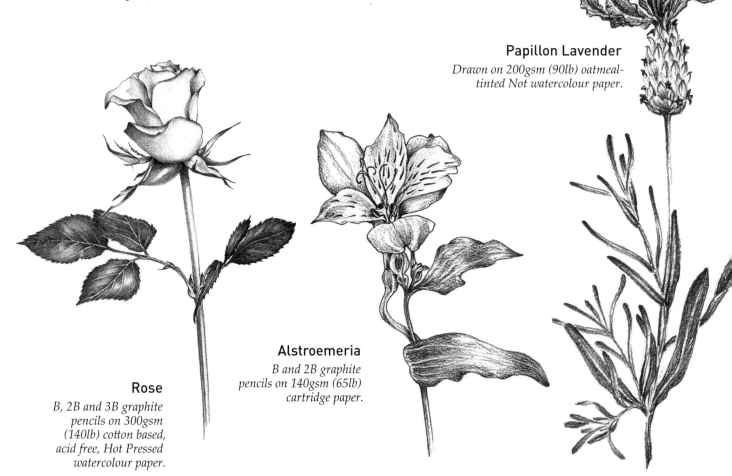

Papillon Lavender
Drawn on 200gsm (90lb) oatmeal-tinted Not watercolour paper.

Alstroemeria
B and 2B graphite pencils on 140gsm (65lb) cartridge paper.

Rose
B, 2B and 3B graphite pencils on 300gsm (140lb) cotton based, acid free, Hot Pressed watercolour paper.

OTHER MATERIALS

Always work on a good, steady base. It will keep your paper still if you are holding a pen or pencil in one hand and a flower in the other. I like to fix my paper to a drawing board with masking tape, a bulldog clip, or a bracket. If you do not have a drawing board, any firm piece of wood or stiff cardboard will do.

A piece of tracing paper or transparent plastic is necessary to place between your hand and the paper to prevent your work from being smudged, as I frequently remind you in this book. You can still see the drawing underneath and it is a good habit to get into.

Keeping your pencil sharp is essential for detailed drawing work. You can use a pencil sharpener or craft knife. I like to use a sharpener that makes a long graceful point and have found one that has three different sized apertures, for thin, medium and thicker pencils, graphite sticks and coloured pencils. I prefer a pencil sharpener that will contain the sharpenings until it is time to empty it and can be kept by my side for instant, frequent use.

If I want a thicker line in ink, I use a bamboo pen or a reed pen. I especially like the softer effect of a reed pen, although it wears down quicker.

Watercolour pencils make a lovely soft line for drawing when kept well sharpened, and I prefer to use a dark colour for this like deep indigo or Payne's gray. I use a water pen for moistening water soluble ink or watercolour pencil. It can be carried easily and is always available. If I have unintentionally used too much water in a small space, I use a cotton bud to soak it up.

A Conté stump is useful for smoothing down part of a Conté drawing, blending colours together or making a soft edge. Cotton buds can also soften the lines and cover a wider area.

I try to use an eraser as little as possible but if I do use one, I like a soft putty eraser. A small piece can be broken off, moulded to a point and dabbed carefully, or stroked gently on the offending mark. When a putty eraser has become dry, it is time to buy a new one. Some artists prefer plastic erasers, which can have their uses, but leave behind pieces of eraser that have to be removed from the drawing. This can cause more smudges.

My favourite pastels come in round pans. The round containers are easily transported as the transparent lids keep them safely screwed together. The small sponges, used for applying the soft pastel, can be fixed on the end of a pencil, and best of all they make exciting, subtle and varied marks when shading either in pale, gentle tones or stronger for effect. Light tones are easily erased with a putty eraser if they go over the line unintentionally.

Clockwise from bottom left: masking tape, bracket, bulldog clip, orchid holders, sharpener, pastel pans, cotton buds, sharpener, putty eraser, plastic eraser, watercolour pencil, Conté stump, bamboo pen, water pen and a craft knife, on tracing paper and a drawing board.

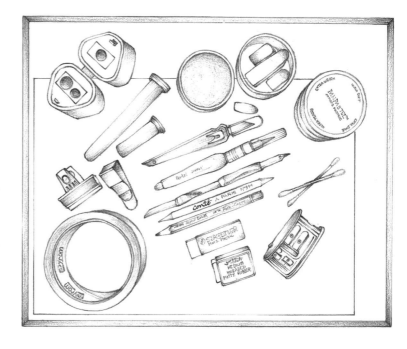

How to start

Make sure you are comfortable and that you have good lighting – daylight is best. Have everything you need on the table: paper, pencils, pencil sharpener or craft knife, tracing paper and eraser (for emergencies only). If your drawing paper is not in a sketchbook or pad, you will need to fix it to a drawing board with masking tape, so that it cannot move.

LINE DRAWING

Hold a single daisy over the drawing paper to decide where to place it and which angle looks best. Notice where the centre of the flower is on the paper. This will be the focal point of your drawing, about a third down from the top of your paper. Your drawing will be life size. Move the daisy to the side of your paper, still holding it horizontally, with a piece of white paper behind it.

Place your HB pencil on the edge of the focal point and, looking at the flower rather than at your paper, let your pencil move on the paper as your eyes move slowly round the circle that is the central disc. When you have completed this, you can look at your paper and place your pencil where a petal starts. Keeping your eyes on the flower, move your eyes slowly round the edge of the petal and move your pencil at the same time. Draw all the petals in this way, only looking at the paper after each petal has been drawn. Every petal will have a different shape and angle. Try not to rub out, as the aim is to get a more spontaneous, looser line drawing. Draw one side of the stalk in the same way but you will need to look at the paper to get the other side of the stalk parallel. Look at the leaf as you draw it.

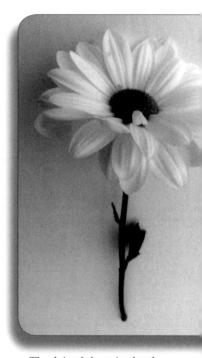

The daisy I drew in the class featured on the opposite page. Each student had their own daisy to draw.

Exercise to show the importance of looking at the flower, not the paper

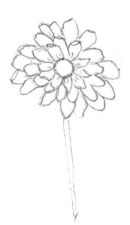

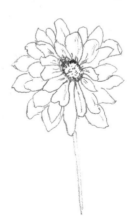

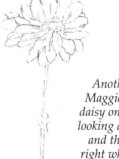

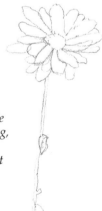

Another student, Maggie T, drew the daisy on the left while looking at the drawing, and the one on the right while looking at the flower.

A) This daisy was drawn by my student, Helen P, while looking mostly at the drawing on the paper.

B) This daisy was drawn by the same student while looking at the flower itself.

A line drawing in stages

I always start drawing a flower in the centre so that it is positioned correctly on the page and all the petals are related to that, in size, angle and shape. This daisy is drawn using just an HB pencil. When drawing the shape, try to look at the flower more than the paper and don't worry if your petal is not exactly the same shape as the petal you are copying. It will be a livelier, more spontaneous drawing if you don't keep rubbing out.

This line drawing is developed with shading on pages 20–21.

1 Using just the HB pencil, draw the shape of the central disc first, near the centre of the page but about a third of the way down from the top. It is important to make sure that the rest of the daisy, in the same scale, will fit on the paper. The obvious petal to start with is the little one overlapping the centre. Starting at the disc, draw the shape of this first petal. Place the next petal to the left and just below it. Draw in the vein faintly.

2 Work round the front row placing adjacent petals, with their veins, round the central disc.

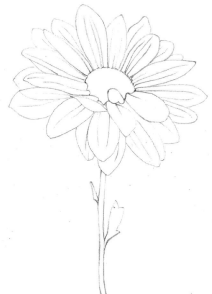

3 Next, work round the circle, placing the second and third rows of petals. If it gets too crowded, you can miss one out. Draw one side of the stalk first, then look at your drawing as you place the other side the correct distance away so that the stalk is the right width. Start drawing the leaves where they join the stalk.

Shading techniques

STARTING TO ADD TONE

This demonstration is developed from the line drawing on page 19, and the shading, like the line drawing is all done with an HB pencil. When shading, you need to look at your drawing longer than at the flower, but keep glancing back at it. Use a small piece of tracing paper or acetate to rest your hand on to prevent the drawing from being smudged.

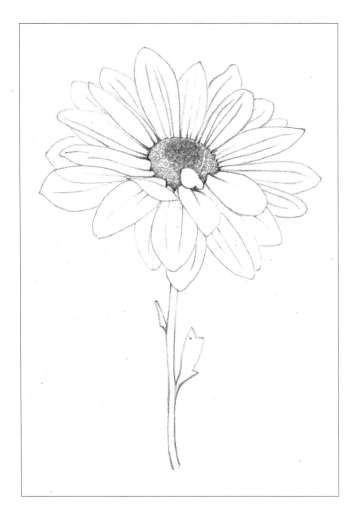

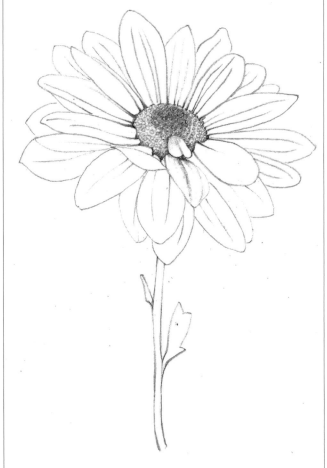

1 Notice how the tiny petals that make up the centre are curled into small circles. They are also darker and more dense in the middle of the domed disc and are arranged in a spiral pattern. Shade these tiny petals with a circular movement of the HB pencil. There are also more shadows, so more circular shading, at the edge of the disc, making it look domed. The base of the petal, where it joins the central disc, is darker in tone. Place your HB pencil at the edge of a petal, next to the disc, and draw it firmly along the pencil line, away from the disc, taking the pencil off the paper quickly. Do the same with each petal. This takes a bit of practice.

2 Starting very faintly, with the pencil hardly touching the paper and using a gentle circular movement, shade the first two petals – the tiny one overlapping the centre and the one next to it. Gradually add more tone, with varied pressure strokes, along the veins and the shadows where the petals join the central disc.

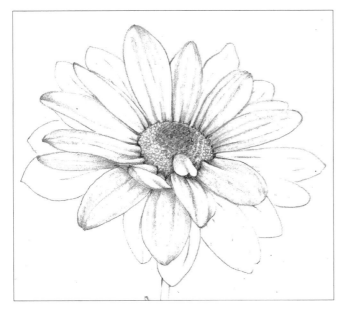

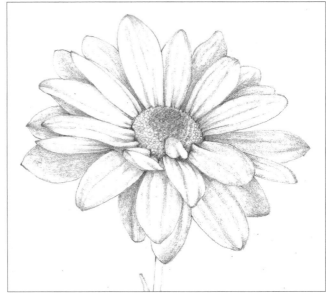

3 Shade the other petals on the front row in the same way, preserving the white highlights. The light is coming from the right, so the left-hand petals are lighter. The tips of the petals appear darker in tone against the white background, especially those on the left, as they curve away from the light source. This can be done using varied pressure strokes. If you have done too much shading and lost the highlights, you can reclaim these using a putty eraser shaped to a point and gently rolling or stroking it along the paper.

4 Shade the other petals, behind the front row, in the same way. Sometimes you need to omit some petals to make a better drawing. Petals that are underneath are darker in tone because more shadows are cast as they go behind the other petals. You might need to emphasise this to make the top petals appear to come forward.

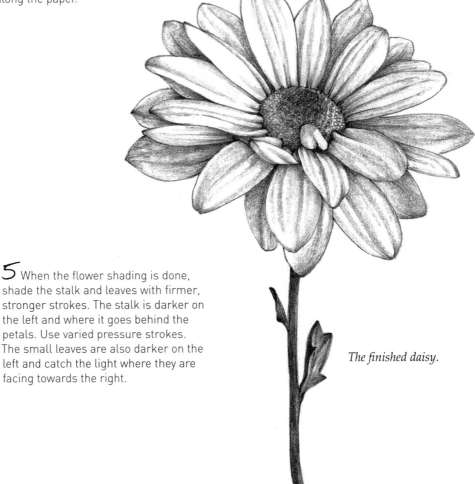

5 When the flower shading is done, shade the stalk and leaves with firmer, stronger strokes. The stalk is darker on the left and where it goes behind the petals. Use varied pressure strokes. The small leaves are also darker on the left and catch the light where they are facing towards the right.

The finished daisy.

MORE DEVELOPED SHADING

I was delighted when my neighbour gave this rose to me after I admired it in her front garden. I started drawing it straight away as they tend to open out very quickly and are then more difficult to draw. I held it in my hand over a piece of white paper. Notice the marked contrast in tone of the leaves compared to the petals. The sepals are the strongest tone of all, which sets off the flower beautifully. I used HB, 2B and 3B graphite pencils.

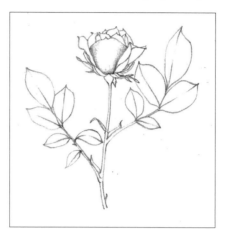

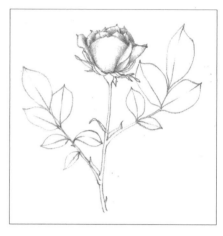

1 Starting with the large petal and working outwards, draw the outline of the rose, looking mainly at the flower, not your paper. Then draw the stalk and the main shapes of the leaves, faintly drawing in the curved midrib on each leaf.

2 Place a piece of tracing paper or acetate under your drawing hand to prevent smudges. Using short, gentle strokes of the HB pencil, shade the large petal, making it darker towards the sides, looking mainly at your paper but frequently glancing at the rose. Use strokes of varied pressure, firmer at the edge and lighter towards the centre, preserving the white highlights.

3 With varied pressure strokes and starting at the darkest part of each petal, shade the other petals in the same way, working round the flower. While shading, your pencil will get a smooth, even tip. Notice where a petal is darker in tone than the one next to it.

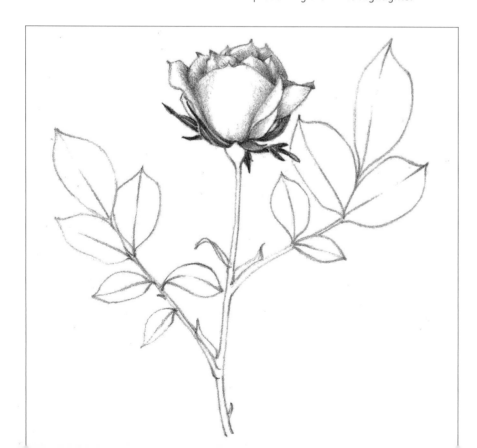

4 Shade the sepals with stronger pressure strokes, darker in the shadows and paler where they face the light from the left. The sepals are much thicker than the petals and they have a very light edge where they overlap each other. Sharpen the pencil to draw their dark, pointed tips.

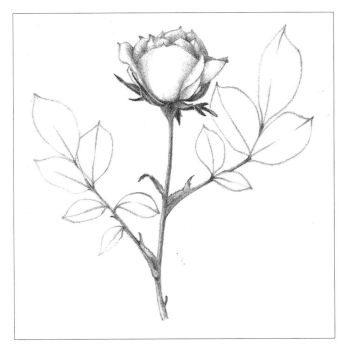

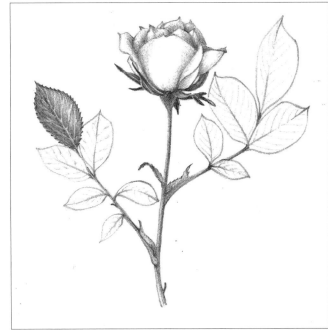

5 It is easier to shade the stalk if you turn your paper sideways. Make the stalk darker on the right-hand side and the underside. Use a very sharp HB pencil for the thorns.

6 Shade the first leaf. Gently pencil in the soft curves of the veins, away from the central rib vein. Use a sharpened 2B pencil to go over the dark, serrated edges of the leaf shapes. Shade the lamina (the main part of the leaf) with varied pressure strokes from the edge towards the centre, taking care to avoid the veins and the even smaller veins attached to them that go to the edge of the leaf. This is like negative painting where the veins are left pale, with darker shading between them.

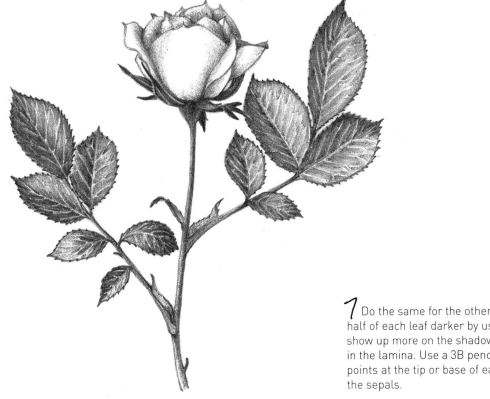

7 Do the same for the other leaves, making the shadowed half of each leaf darker by using the 2B pencil. The veins show up more on the shadowed side as they are recessed in the lamina. Use a 3B pencil to further define the darkest points at the tip or base of each leaf and the darkest part of the sepals.

PEN AND INK SHADING

Shading can be achieved in various ways. Some artists prefer to use hatching, i.e. small lines close together, and cross hatching, i.e. small lines crossing the hatching lines, as in examples 3 and 4. I sometimes use a water soluble pen to draw the flower and then create the shading with a water pen as in example 2. With acrylic ink and a dip pen you can experiment with different pens and brands of ink to see which suits your style. The flexible nib is more difficult to control than other pens, but creates some interesting effects. After dipping the nib in ink, you need to wipe it against both sides of the bottle before drawing on the paper. Sometimes blobs and drips occur, but I usually welcome these as they add excitement to the drawing. Acrylic and Indian ink are both easily smudged as they take a long time to dry but you can sometimes cover this by adding an extra leaf.

1

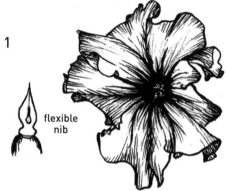

flexible nib

2

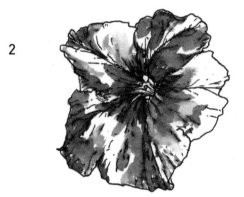

Petunia in acrylic ink and flexible nib

The intensity of the tones in the centre of this petunia flower is achieved by making the curved hatching lines closer together, so that they meet at its darkest point. The curved hatching follows the contours of the petals. The flexible nib makes a much broader line when pressure is applied.

Petunia in water soluble drawing pen and water pen

First the outline of the petals and their veins is drawn, then curved shading lines following the shape of the petal and fine veins. This soon dries and the water pen can be applied where there are shadows in the direction of the veins. Care has to be taken not to overdo this process and make sure some dry paper is left to show the lighter parts. The ink stains the paper and is impossible to remove, once applied.

3

4

static nib

Petunia in artist's sketching pen

The petunia I used for this had a lovely velvety texture. The pen makes darker lines when first applied to the paper, going fainter as you lift it off. It also gets fainter the longer you use it, so it makes lighter shading. You need to put this pen on the paper either at the centre of the flower or at the tip of a petal, drawing it towards the centre. Cross hatching on the darker left-hand side gives the petunia a three-dimensional quality.

Petunia plant in acrylic ink using a more static nib

This drawing shows some hatching and some cross hatching, but generally I prefer to use the veins and the contours of the flowers and leaves to show the form. You can turn the pen over and use the back of the nib for finer lines of shading.

Dahlia in water soluble pen and water pen

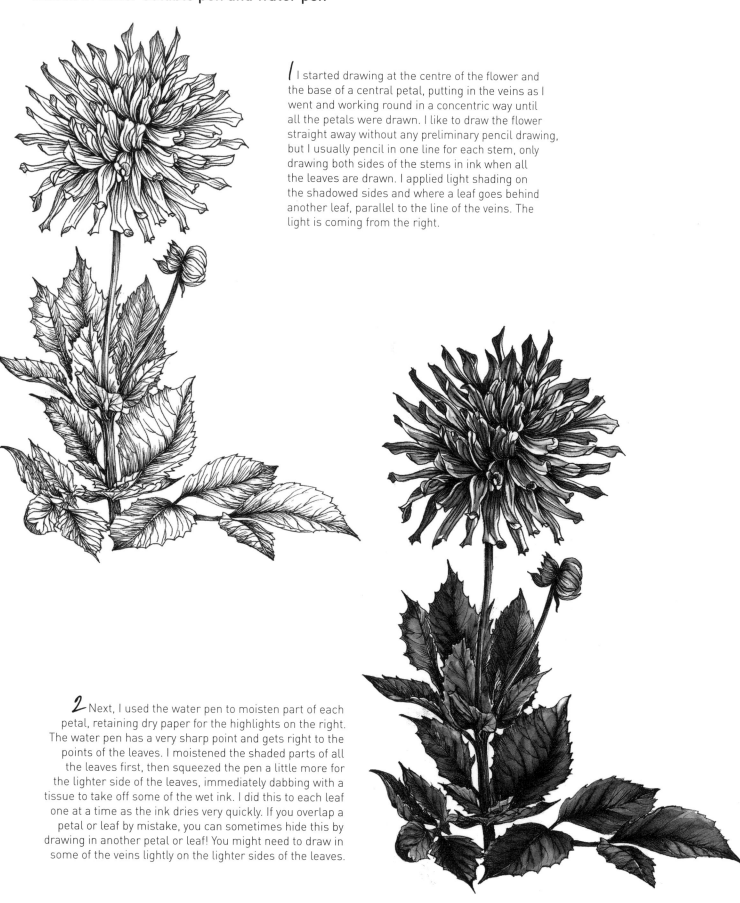

1 I started drawing at the centre of the flower and the base of a central petal, putting in the veins as I went and working round in a concentric way until all the petals were drawn. I like to draw the flower straight away without any preliminary pencil drawing, but I usually pencil in one line for each stem, only drawing both sides of the stems in ink when all the leaves are drawn. I applied light shading on the shadowed sides and where a leaf goes behind another leaf, parallel to the line of the veins. The light is coming from the right.

2 Next, I used the water pen to moisten part of each petal, retaining dry paper for the highlights on the right. The water pen has a very sharp point and gets right to the points of the leaves. I moistened the shaded parts of all the leaves first, then squeezed the pen a little more for the lighter side of the leaves, immediately dabbing with a tissue to take off some of the wet ink. I did this to each leaf one at a time as the ink dries very quickly. If you overlap a petal or leaf by mistake, you can sometimes hide this by drawing in another petal or leaf! You might need to draw in some of the veins lightly on the lighter sides of the leaves.

Using Conté crayons

Conté crayons are unique, firm drawing sticks that can make a wide variety of rough or smooth marks, as demonstrated in this step by step study. They are more controllable and also have the advantage of making less dust than conventional soft pastels.

POT OF DAISIES

These daisies were flowering in my garden and looked so delightfully asymmetrical in this plant pot that I took a photograph and drew them exactly as they were. Each daisy is at a different angle and has a unique shape and arrangement of petals, so it in important to keep looking at the flowers while you draw.

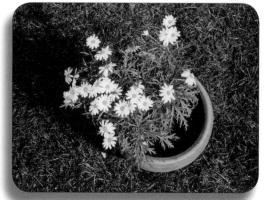

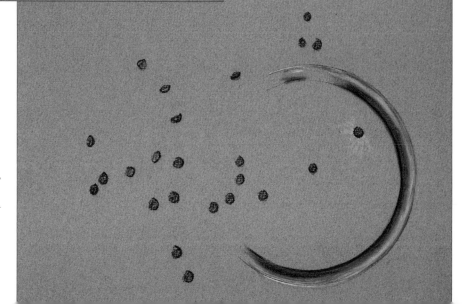

1 On tinted pastel paper, using white and sanguine Conté pencils, I drew round two different saucers to make the perfect shape for the pot, which I then shaded in with white and sanguine Conté crayons. I blended these together carefully with a cotton bud to make them smooth.

2 I drew the centres of the daisies with white Conté crayons and blended them with sanguine Conté crayons, making a shadow round the rim on the right-hand side of each one.

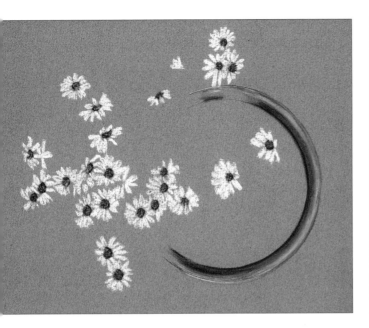

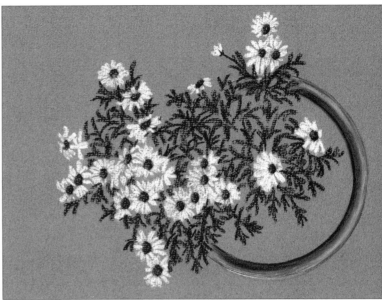

3 I drew round each daisy petal with white Conté crayon, starting at the daisy's central disc, going round the shape, then back to the disc. Each one needs careful study to make them look convincing.

4 I drew the leaves with sepia Conté crayon, roughly in the place and shape where they were. There are too many in the photograph to draw every one and the daisies themselves give the shape of the arrangement. I also used sepia to strengthen the shadows on the central discs of the flowers.

The finished drawing

At the final stage, I filled in the soil area inside the pot loosely with black Conté crayon and also the negative spaces between the leaves, leaving some paper showing round the edge of the leaves and flowers. I used the saucers again to delineate the rim of the pot in the spaces behind the leaves and flowers, and smoothed this in again with the cotton bud.

Lost and found edges

Many drawings, in any medium, can be improved by the use of 'lost and found' edges. A continuous, even line round the subject is not as interesting as a line that fades or even disappears in the correct places. This is particularly true of flower drawings, where the delicate nature of petals, and sometimes leaves, is portrayed more accurately with a broken line, as if the light is striking the flower on the edge of the petals on one side. In a pencil or graphite drawing, if you have completed the initial drawing in a fairly continuous line, you can 'lose' the appropriate edges with the careful use of a pointed piece of putty eraser.

This is a simple line drawing in 1B and 2B graphite pencil with various sources of light. It was done on Hot Pressed (smooth) watercolour paper.

This is a more complete botanical drawing in 1B and 2B pencil with the light coming from the top right, also on Hot Pressed watercolour paper.

These are dark-toned burgundy/purple flowered magnolias, drawn with a pure graphite stick on Hot Pressed watercolour paper. I really loved the graceful shapes of the petals, bud and leaves. The light is coming from the right.

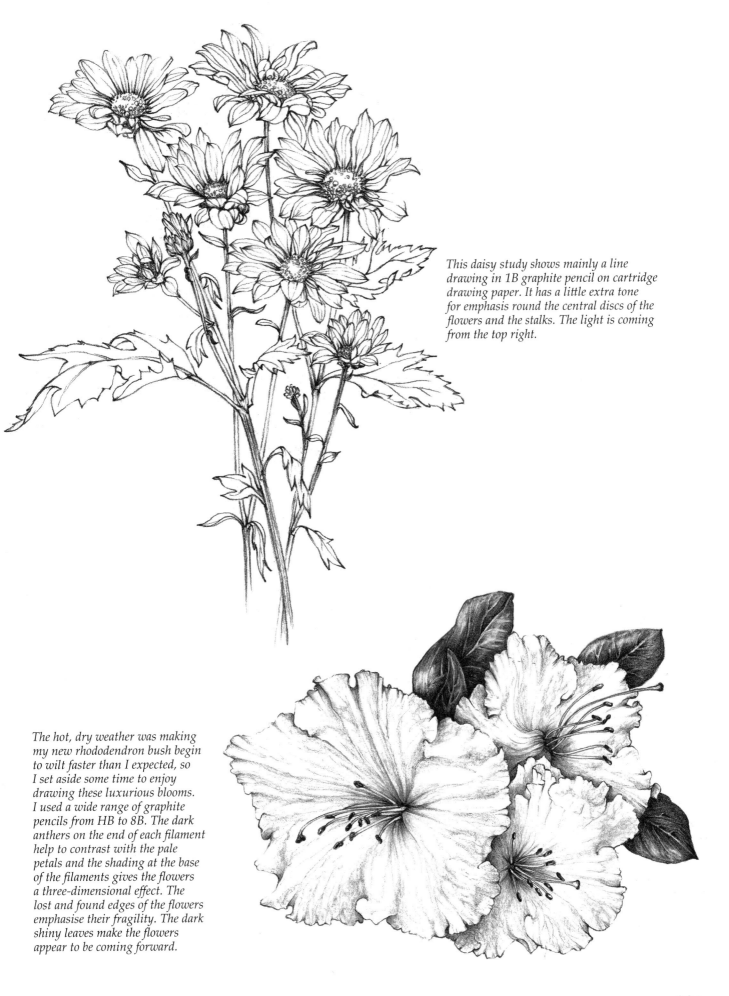

This daisy study shows mainly a line drawing in 1B graphite pencil on cartridge drawing paper. It has a little extra tone for emphasis round the central discs of the flowers and the stalks. The light is coming from the top right.

The hot, dry weather was making my new rhododendron bush begin to wilt faster than I expected, so I set aside some time to enjoy drawing these luxurious blooms. I used a wide range of graphite pencils from HB to 8B. The dark anthers on the end of each filament help to contrast with the pale petals and the shading at the base of the filaments gives the flowers a three-dimensional effect. The lost and found edges of the flowers emphasise their fragility. The dark shiny leaves make the flowers appear to be coming forward.

Petals

Petals are the most conspicuous part of the flower and are therefore most important. Whether they are pale or dark, the drawing needs to describe how delicate they are, though some are more delicate than others. The plant uses its petals to attract butterflies, bees and other insects for pollination and the shapes, textures and colours vary enormously. There is such a wide variety of petal shapes, textures and tones that I have only illustrated a few here. These examples are all drawn with water soluble pen, moistened with a medium-sized water pen.

Hibiscus

Rose

Clematis 'Crystal Fountain' – pale purple

Clematis 'The President' – deep purple

Parrot tulip – burgundy and white

30

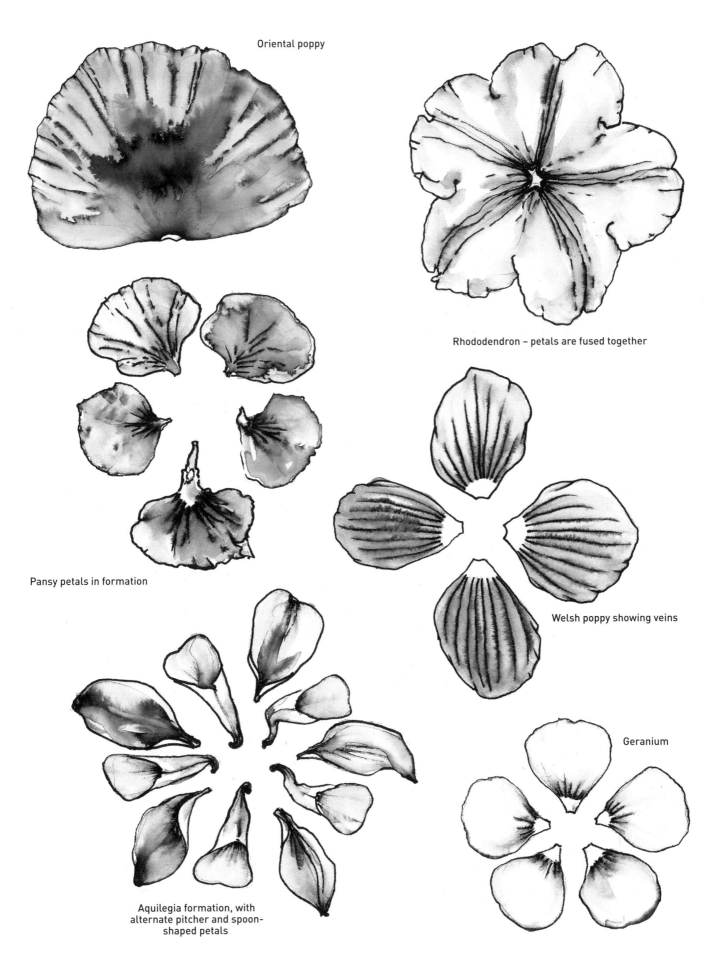

Oriental poppy

Rhododendron – petals are fused together

Pansy petals in formation

Welsh poppy showing veins

Geranium

Aquilegia formation, with
alternate pitcher and spoon-
shaped petals

31

Leaves and stems

Leaves and stems are the natural accompaniment to flowers and can provide a strong contrast in tone. Many leaves have wonderful shapes and I sometimes find that I have enjoyed drawing the leaves, with their twisted, overlapping shapes and varying tones almost more than the flowers. There are countless leaf shapes that are too numerous to show here.

Stems are necessary to support the flowers and leaves but must not be too conspicuous or dominant. Leaves are generally more varied in tone than the flowers, especially if they are shiny, and they can give a strong indication of where the light is coming from, as can the stems. Overlapping leaves and stems are generally lighter than those behind them. Occasionally those behind are lighter if they are turning towards the light source, or have reflected light from the other side. When drawing leaves, you should also observe the shape and arrangement of the veins. There is a stronger central midrib with veins branching out from that and even smaller veins attached to those. This forms the 'skeleton' framework of the leaf and supports the lamina; the flat part of the leaf. Careful observation is necessary concerning the pattern of veins, for instance, are they alternately branching out or in opposite pairs, or staggered? Sometimes the veins are almost parallel, starting at the base of the leaf and joining at the tip. Leaves and stalks are sometimes smooth and shiny and sometimes hairy and textured. Leaves are attached to the stalks in different ways and sometimes have an axillary bud between the petiole (leaf stalk) and stem.

You need to look carefully at your specimen.

Welsh poppy – a compound leaf with serrulate edges

The five leaf shapes showing veins on this page were drawn in acrylic ink and dip pen.

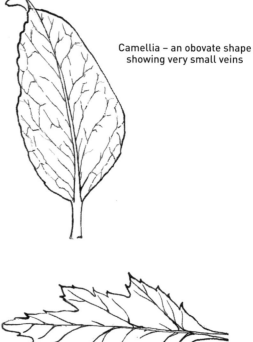

Camellia – an obovate shape showing very small veins

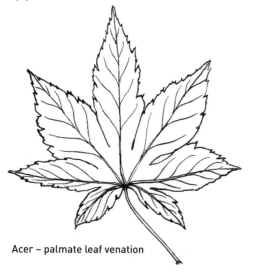

Acer – palmate leaf venation

Chrysanthemums with palmately lobed leaf edges

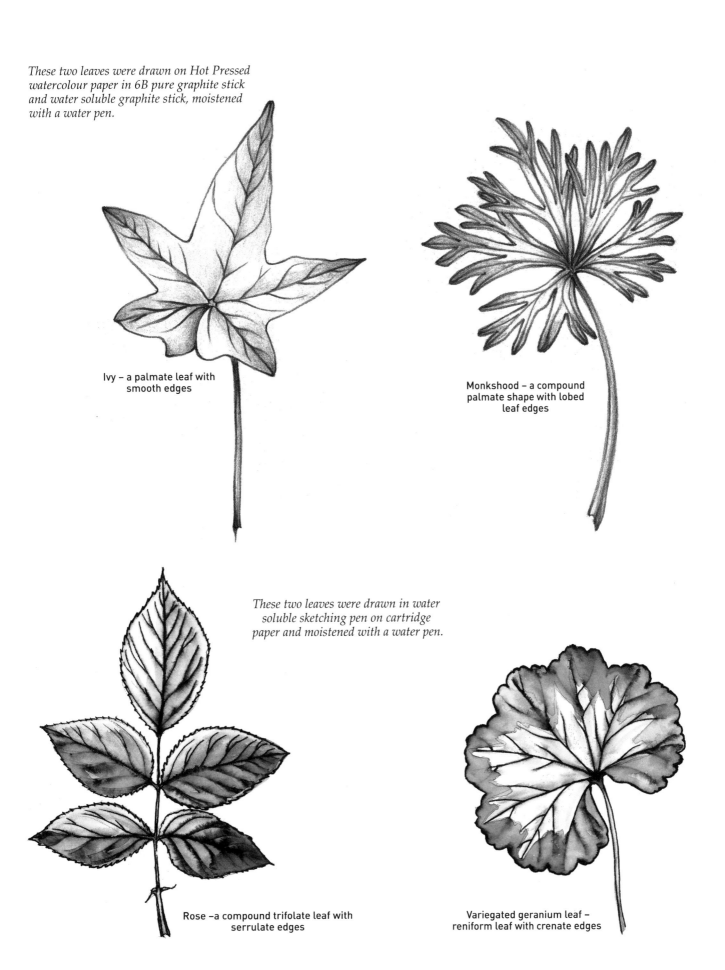

These two leaves were drawn on Hot Pressed watercolour paper in 6B pure graphite stick and water soluble graphite stick, moistened with a water pen.

Ivy – a palmate leaf with
smooth edges

Monkshood – a compound
palmate shape with lobed
leaf edges

These two leaves were drawn in water soluble sketching pen on cartridge paper and moistened with a water pen.

Rose –a compound trifolate leaf with
serrulate edges

Variegated geranium leaf –
reniform leaf with crenate edges

These leaves were drawn in graphite pencil on Hot Pressed watercolour paper, to show the different textures.

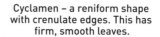

Cyclamen – a reniform shape with crenulate edges. This has firm, smooth leaves.

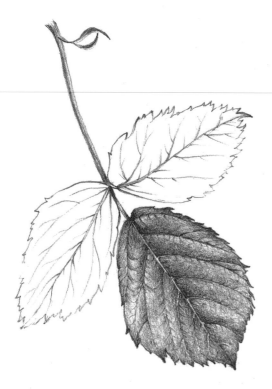

Camellia – an obovate shape with crenulate edges. This has dark, thick, shiny leaves.

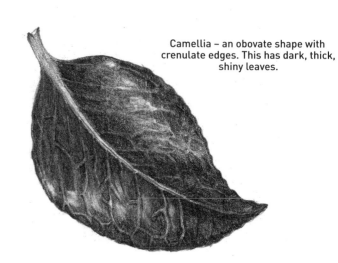

Bramble – a compound, trifolate leaf with serrulate edges. This has soft, matt leaves.

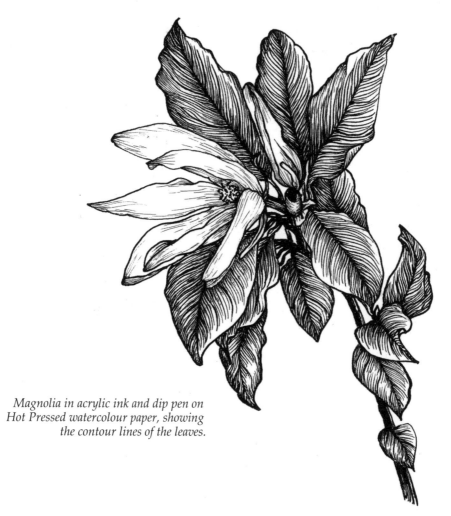

Magnolia in acrylic ink and dip pen on Hot Pressed watercolour paper, showing the contour lines of the leaves.

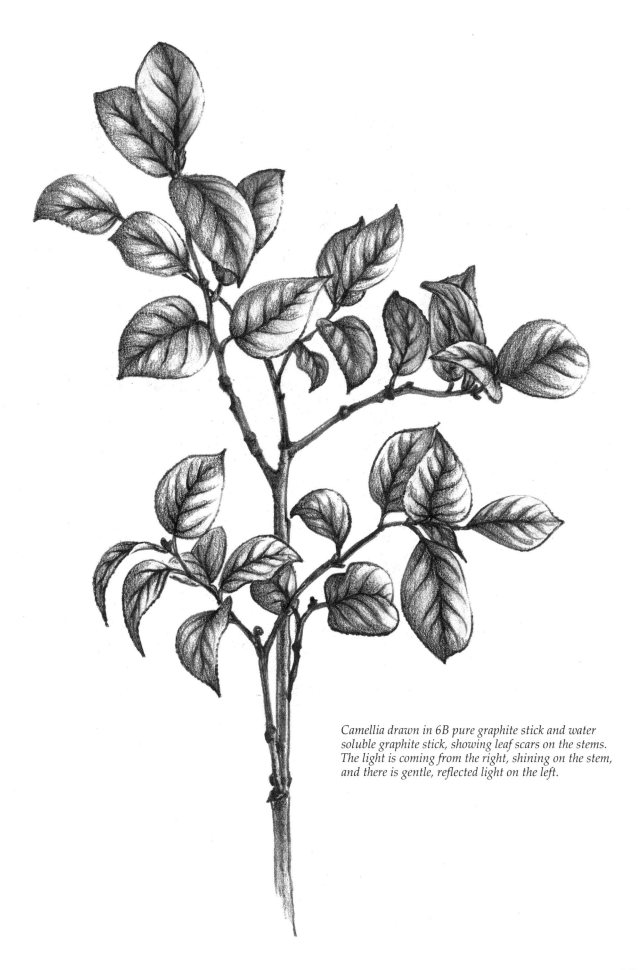

Camellia drawn in 6B pure graphite stick and water soluble graphite stick, showing leaf scars on the stems. The light is coming from the right, shining on the stem, and there is gentle, reflected light on the left.

Using photographs

Some people find it easier to work from photographs. Many flowers only last a few days before drooping; others are in gardens where they cannot be picked and sometimes you do not have time to draw them when they are given to you. For these and other reasons, you need to take clear photographs to work from later. Place the flower on a large piece of white (or black) paper and photograph it from above without a flash, in good light but not direct sunlight. It could be outside in the shade on a bright day, or inside in a well-lit room. If you are inside, you could arrange a light to shine from one side, which helps to give three-dimensional form to the flower. If it is growing in the garden, you could get someone to hold a piece of blank card behind it, to simplify the background. If you have a digital camera, you can take several photographs, then choose the best one.

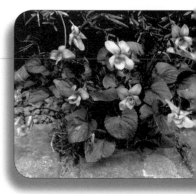

The reference photograph.

Violets Growing by a Garden Path

This photograph shows a good tonal contrast between the dark leaves and light flowers. It is also a very compact plant, which helps give a natural composition. I drew the outline first. Next I shaded the leaves and dark stems with 2B, 4B and 6B graphite pencils before gently shading the petals with a B pencil, leaving some white paper for the highlights but making the centres darker with 2B. As the plant was growing in the garden, I very gently shaded the ground around the base of the plant to indicate the shadows.

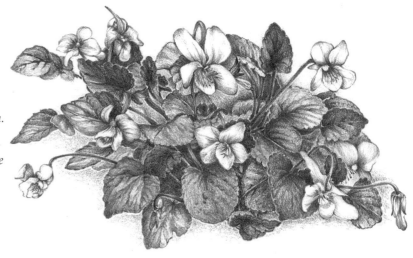

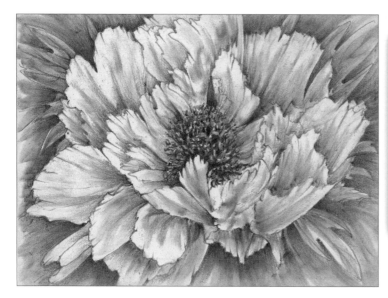

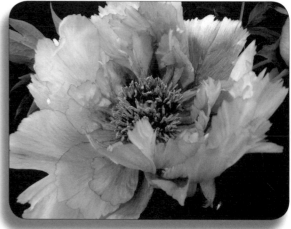

Tree Peony

I decided to draw this flamboyant flower loosely with broad pastel strokes to give the initial tones, then 4B graphite stick to delineate the petals and leaves. I drew some extra leaves on the right to balance the picture.

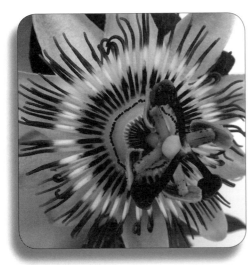

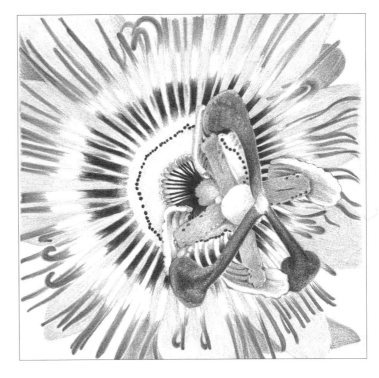

Passion Flower

I loved the dramatic effect of this flower, which I photographed from a slight angle to show the three-dimensional form and its circular, radial symmetry. I drew the outline first with an F pencil, then started the shading from the top of the flower with the three styles and stigmas, in 4B graphite stick, using a rotating movement. Next the round ovary was shaded very slightly towards the top. I then shaded the four pale filaments (with 2B and 4B pencils) and the even paler anthers at the ends. The ring of dark spots (nectaries) were strongly drawn with an 8B pencil. The ring of the many multicoloured corona was also shaded in 8B pencil nearer the centre, left white with lost and found edges in the middle, and shaded with soft 4B graphite stick towards the ends. The central dark lobes were shaded very strongly with 8B graphite pencil. Finally the ten outer petals and sepals were very faintly shaded with B graphite stick.

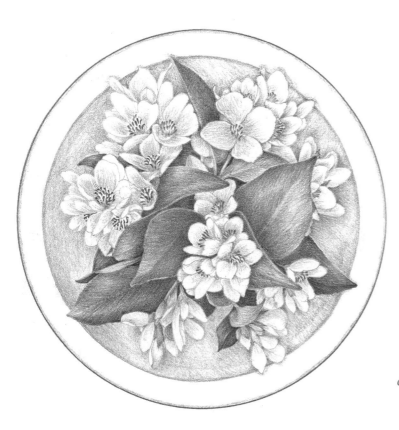

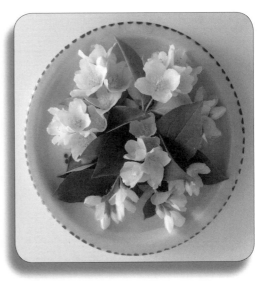

Orange Blossom

The small groups of orange blossom were floated in a plate of shallow water. This photograph appealed to my sense of balance, with the contrasting perfect circles enclosing the randomly arranged orange blossom. I drew round two plates for the circles with 4B pencil, then drew the outline of the blossom. I shaded the leaves first with 6B pencil, then the petals with 2B pencil, and finally the stamens in the centre of each flower were indicated with strong, quick marks in 8B pencil.

Using sketchbooks

Sketching is a way of expressing, in line and tone, what you can see that you could not describe in any other way. For me, its main purpose is to enjoy making a permanent record of my personal reaction to the visual world. I can share this pleasure with friends and family in a way that is more personal and expressive than photographs. I almost always have a sketchbook with me when I travel, go on holiday or am waiting for a meal. I will draw anything that 'takes my eye'. It is important to get in the habit of using sketchbooks. The opportunities are all around you.

Breakfast table arrangement at the Ship Inn, on A5 cartridge paper with B, 4B and 6B graphite. We waited a long time for breakfast to arrive!

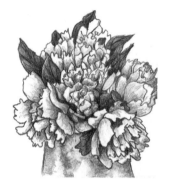

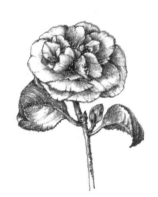

Camellia on A5 cartridge paper in 8B graphite and white Conté. This was growing in my mother's garden when I picked it. There were hundreds of flowers on the bush.

Table arrangement at the George Hotel, on A5 cartridge paper in 6B graphite.

Two cottage garden scenes in Wiltshire – both on A4 cartridge paper in 8B graphite. I had a lovely day sitting in this beautiful garden in the sun, sketching with some of my students.

Flowering bushes at the Crab and Lobster, on A5 cartridge paper in 6B graphite. The meal was over and I couldn't resist making a quick sketch of this.

Garden scenes on A3 pastel paper in watercolour pencil. One is in France, the others in Surrey. Both are useful examples of quick, loose sketching outdoors.

Lisianthus on A5 cartridge paper in Conté. The white Conté blends the darker colours together smoothly for an interesting effect.

Italian garden on A4 cartridge paper in artist's pen and pastel. I had very little time for this and the ducks kept moving around. It was also rather cold!

Gladioli

This demonstration has been drawn in water soluble ink, which bleeds out several subtle colours when diluted.

MATERIALS

A3, 300gsm (140lb) Hot Pressed watercolour paper

Dip pen with fine flexible nib and thicker, rigid nib

Water soluble ink

Water pen

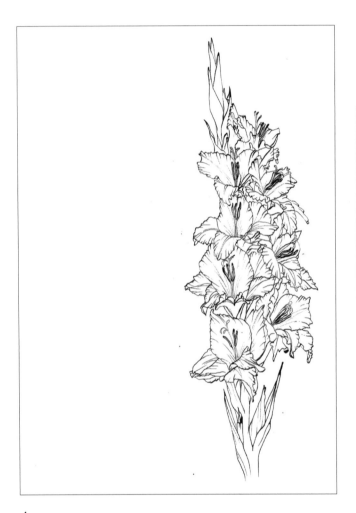

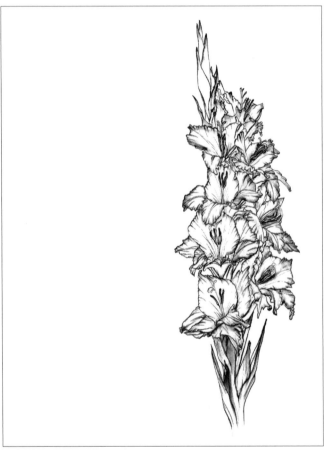

1 Using water soluble ink and a fine flexible nib, draw the outline of the first gladiolus, starting at the top and leaving space on the left of the paper for the other two. Press down more for a thicker line and less for a thinner line to vary the effect.

2 Apply water pen down from the tips of the flower spikes, pressing firmly at first, then lifting it off, dabbing occasionally with tissue if there is too much ink or water. The fine synthetic bristles are easy to guide and the brush always keeps a very sharp point. Do the same with the flowers, keeping the point inside the petals and drawing it down towards the centre of the flower, following the direction of the veins but avoiding the anthers and sepals. At this point I added another leaf on the bottom right-hand side to make it more balanced.

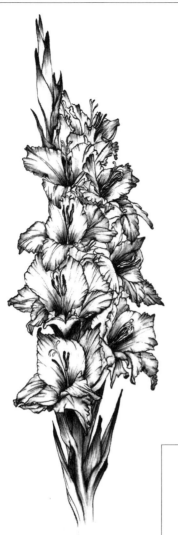

3 Add some more shading with the pen from the centre of each flower upwards and then more hatching to the stems and leaves. Moisten each flower with the water pen, avoiding the anthers and sepals again. Wet the stems and leaves.

4 The second gladiolus is a deep purple and mauve colour, so use a slightly thicker, rigid nib to draw the outline on the left of the page, still using water soluble ink and hatching the lines closely to give a deeper tone. Turn the pen over to use the back of the nib for the finer veins. There are also some deep purple blotches of a deeper tone on these petals.

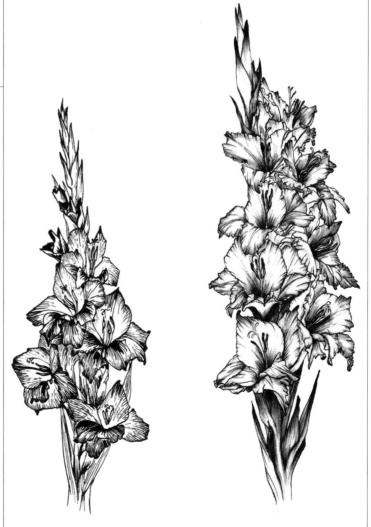

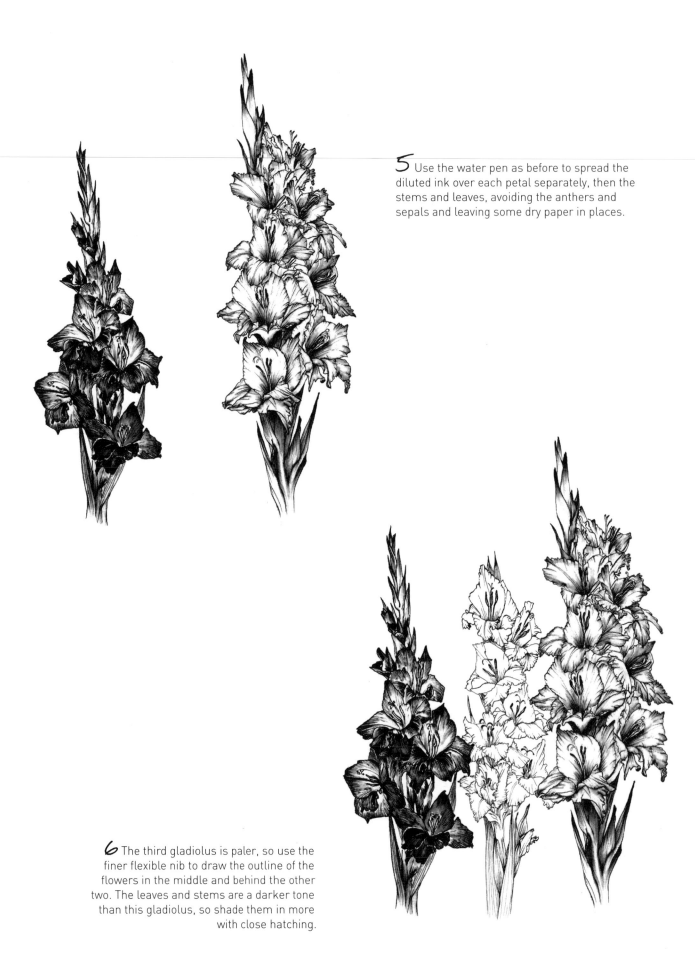

5 Use the water pen as before to spread the diluted ink over each petal separately, then the stems and leaves, avoiding the anthers and sepals and leaving some dry paper in places.

6 The third gladiolus is paler, so use the finer flexible nib to draw the outline of the flowers in the middle and behind the other two. The leaves and stems are a darker tone than this gladiolus, so shade them in more with close hatching.

The finished drawing

At the final stage, add minimal shading with the water pen on the third flower to keep it light. Finally, add some more opening buds to the dark gladiolus on the left.

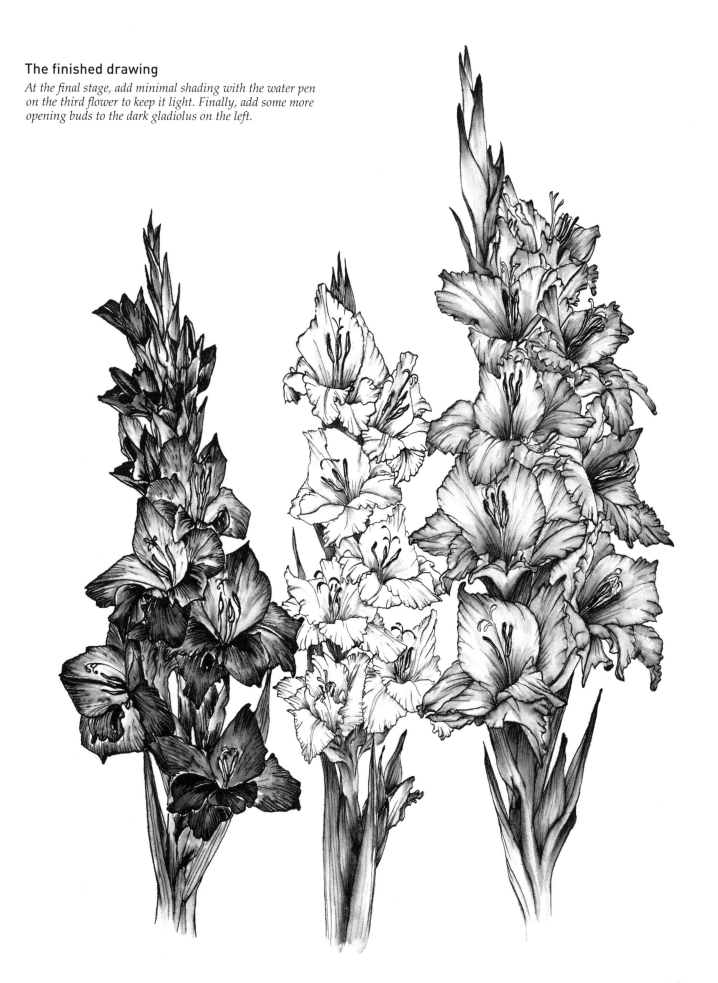

Hollyhocks

Hollyhocks grow tall in my garden every year. They soon go limp after cutting, so I did the initial drawing in graphite, sitting in the garden. You need to protect the drawing from being smudged by using a piece of tracing paper or transparent acetate under your drawing hand, at all stages. It was quite frustrating as it kept raining, but I am quite pleased with the result. After doing the initial drawing, I brought different flowers, buds and leaves into my studio and put them in a saucer of water to get the details right.

MATERIALS

A3, 300gsm (140lb) Hot Pressed watercolour paper

Tracing paper or transparent acetate

HB, 4B, 2B and 8B graphite pencils

3B, 4B, 8B and 9B graphite sticks

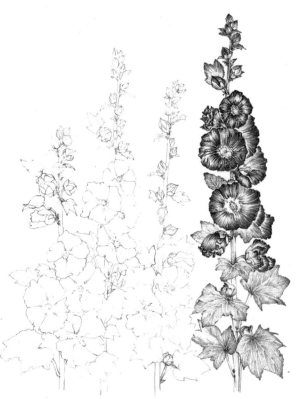

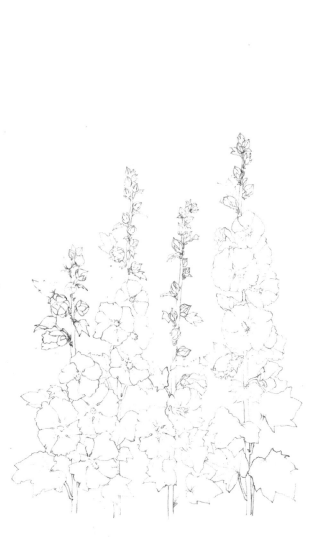

1 Draw the outline of the hollyhocks in HB pencil, taking care to vary their height and the position of the main flowers. Notice the way the leaf stalks join the main stems. Take the main veins to the points of each leaf in a faint curved line. Most of the leaves are palmate – with five points.

2 Start gently shading the buds at the top of the first hollyhock with a 3B graphite stick, in a curved direction, from top to bottom. Then use a sharp 4B pencil to strengthen the points and edges at the top with a varied pressure line. The light is coming from the right. I added some seed pods growing on stalks near the leaves below the flowers. Shade the leaves with a 4B graphite stick, in the direction of the veins, but avoiding darkening the actual lines of the veins. Make the edges of the veins crenulated with a sharpened 4B pencil and emphasize where the smaller veins join the main veins. Shade the flowers with an 8B graphite stick, in a curved line from the outside towards the centre. Next draw the veins of the petals from the circle surrounding the centre towards the middle of each petal. There are five petals on each flower. The carpel in the centre of each flower is fluffy and elongated, mostly seen from the front. The main stem is shaded on the left and speckled in places.

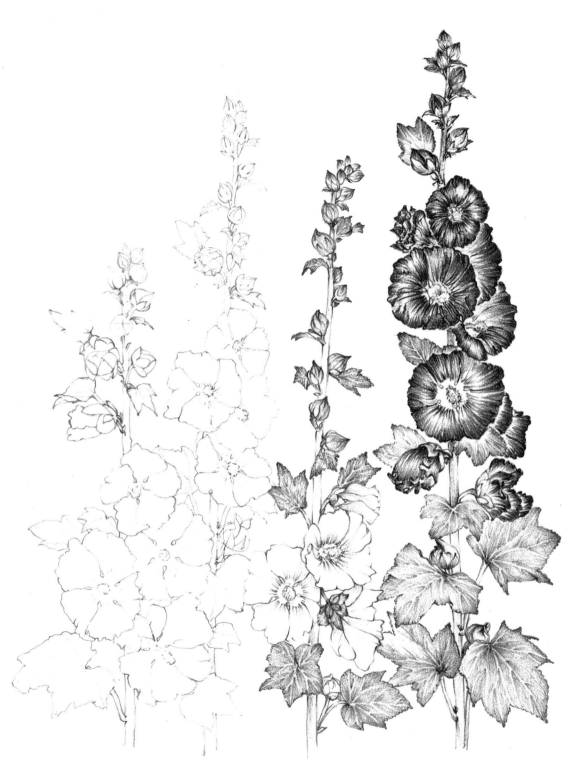

3 The second hollyhock has pale white flowers and more buds on the main stem. You can see the veins on the petals more clearly on these, so stroke them in gently with a 2B pencil, from the inside out, following the contours of each petal. You can also see the shape of the petals better on these flowers. Leave the main part of the petals as white paper. Shade the buds, stems and leaves in the same way as in step 2, making the leaves darker in tone. The double row of sepals behind the flowers is interesting viewed from the rear.

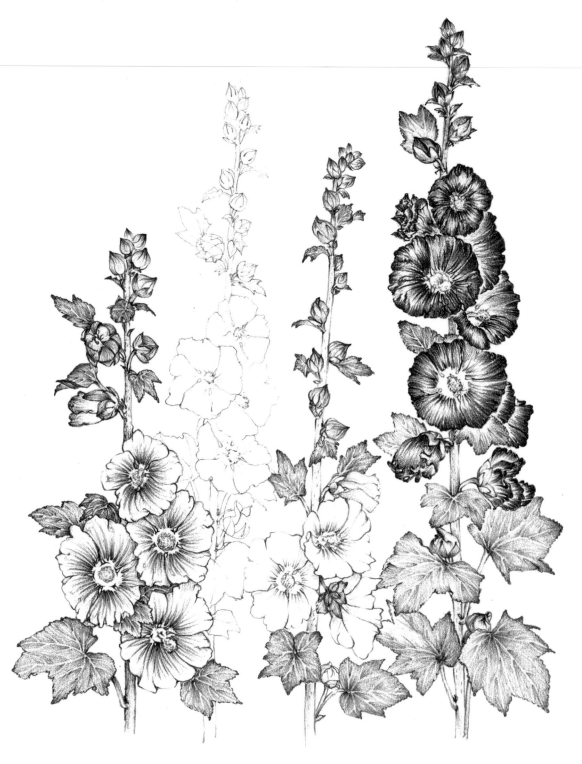

4 The hollyhock on the left has medium-toned pink flowers, and you can clearly see the shape of the carpel, in the centre of the lowest flower, from the side. Stroke in the veins on these flowers with a 4B graphite stick, starting near the centre. Again, the leaves are a darker tone than the flowers.

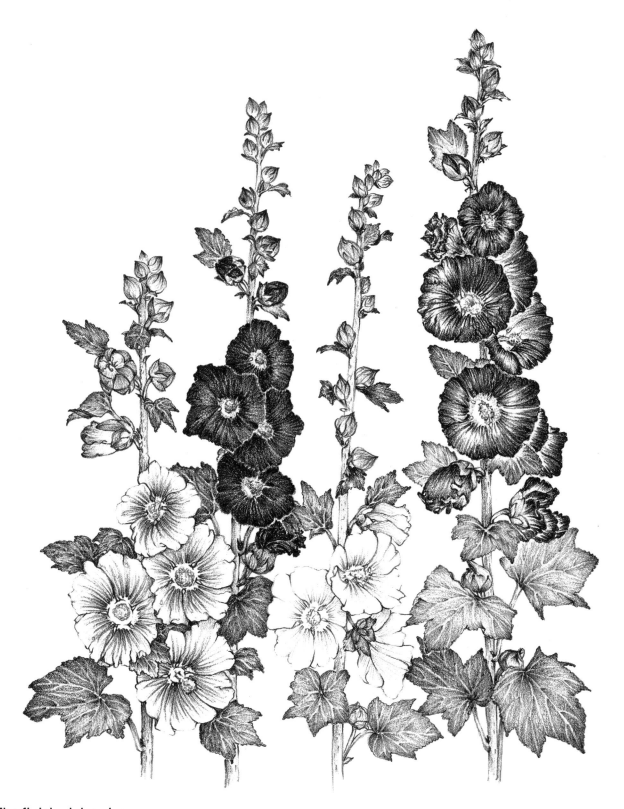

The finished drawing

The fourth hollyhock is a dark, rich burgundy colour and is set back slightly behind the others. At the final stage, shade the petals with strong curved strokes of an 8B graphite stick and make the leaves slightly darker with 4B graphite, where they go behind flowers. I turned a seed pod into a dying flower below the last opened flower to bring the darker tone down the stem. Now that all hollyhocks have been shaded, you can go round the entire drawing with an 8 or 9B graphite stick and 8B graphite pencil, checking or strengthening the tones where necessary, especially towards the points of the lower leaves. You can use a small piece of putty eraser, shaped into a point, to lighten or remove some of the lines around the palest flowers to give a 'lost and found' interest to your drawing. You could also use the putty eraser to gently remove shading from the leaves if they have become too dense in the middle.

Penstemon

I have grown penstemon in my garden for many years. They come in many different varieties and have wonderfully organic shapes. They are often used in a supporting role in my mixed flower studies, but this 'Giant Flowered' penstemon is so flamboyant that it is a 'prima donna' in its own right.

MATERIALS

A4, 300gsm (140lb) Hot Pressed watercolour paper

Tracing paper

HB, 2B, 4B, B, 6B and 8B graphite pencils

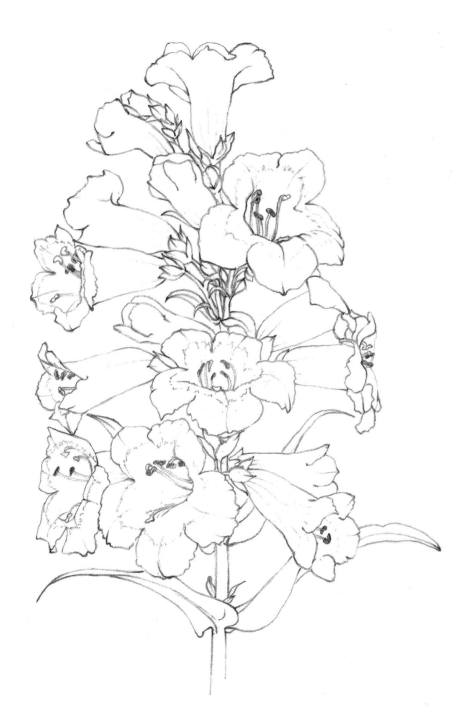

1 Make a faint vertical line with an HB pencil to indicate the position of the main flower stalk, curved at the top. Starting at the top, draw the outline of the flowers with their sepals, followed by the buds and leaves. The stem leaves are smaller than the basal leaves.

2 Shade the outside petals of the three main flowers in 2B pencil with varied pressure strokes, strongest on the outside and curving towards the centre. Keep turning the paper round at right angles for the shading. Use a spare piece of tracing paper to rest your hand on as you draw to prevent smudging. Leave the centres of the flowers as mainly white paper but with gentle shading from the deepest part of the bell shapes, avoiding the stigma and style on their long stalks. With a 4B pencil, strengthen the shading from the edges of the petals.

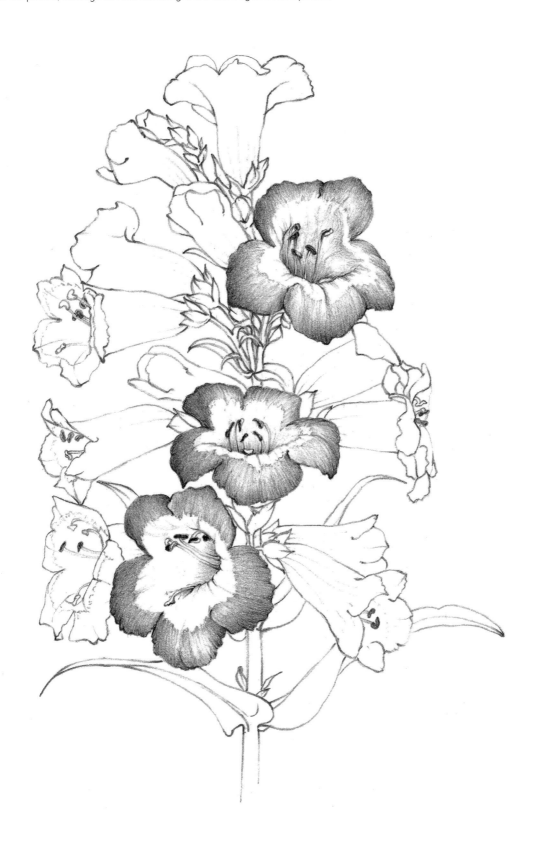

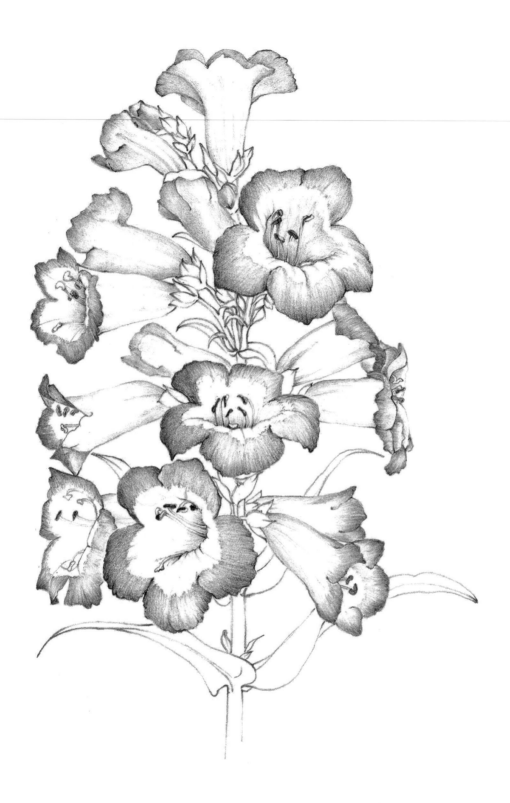

3 Using only B and HB pencils, shade the flowers and buds at the side and the back, keeping them more subdued in tone. Keep the shading even paler at the point where these flowers were overlapped by the main flowers.

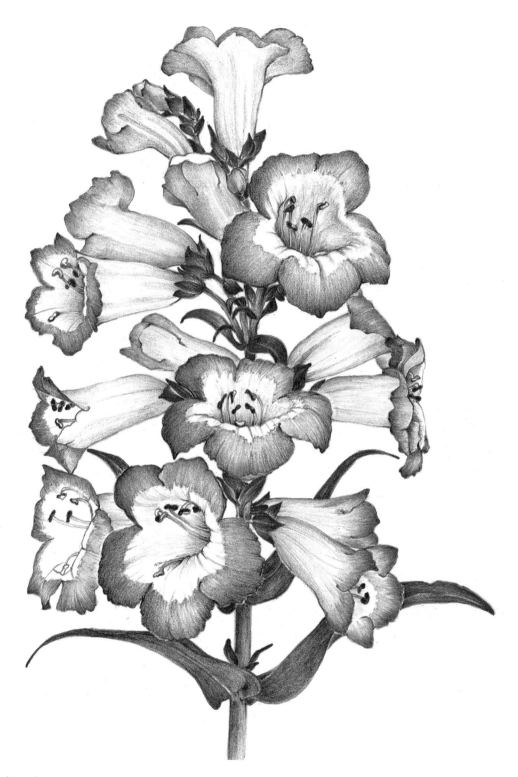

The finished drawing

At the final stage, shade the sepals, stem leaves and stalks, using strong strokes, with a very sharp 4B pencil. Start at the tip and make the strokes lighter nearer the base. Use curved strokes with 4B and 6B pencils, to show the shape and curves of the large basal leaves which are darker at the points and bases, with much lighter central veins. Intensify the tone at the extreme points of the petals and leaves with a very sharp 8B grade pencil.

Stargazer Lilies

I saw these lilies in my local florist's shop and knew they were just the kind of flower I like to draw most. They have an interesting shape, detailed markings on the petals and wonderfully expressive leaves. The perfume, which is almost overpowering, is a bonus. Lilies make a good subject for drawing from life as the flowers last for several days.

MATERIALS

A4, 300gsm (140lb) Hot Pressed watercolour paper
HB, B and 6B graphite pencils

1 With an HB pencil, draw the outline of the first lily, starting with the sepals in the centre of the flower. Stargazer lilies have two rows of petals, so draw the three on the inner row first, then the three that are behind the spaces in between. Each petal is an individual with a slightly different shape, so you need to look carefully.

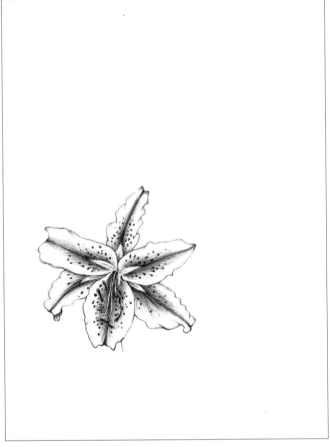

2 Using a B graphite pencil, use short strokes to gently shade the edges of each petal, from the edge inwards. Then, still with the B pencil, use curved strokes from the central vein of the petal towards the outside, followed by stronger strokes with a 6B graphite pencil, nearer the central vein. Use the 6B graphite pencil for the 'spots', which are more tear-shaped than circular, and are slightly raised up from the petals.

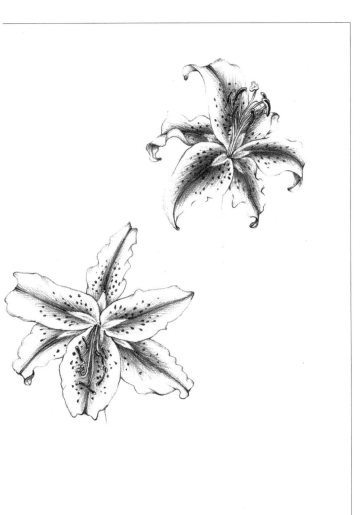

3 Draw the outline of the next flower, again with the HB
pencil, noticing that these are more curved petals than the
first and this one has a more upright manner. Complete the
shading in a similar way to the first flower.

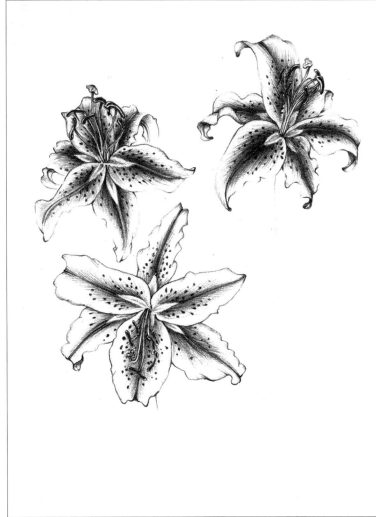

4 Do the same with the third flower, drawing the sepals first
and the 'spots' last.

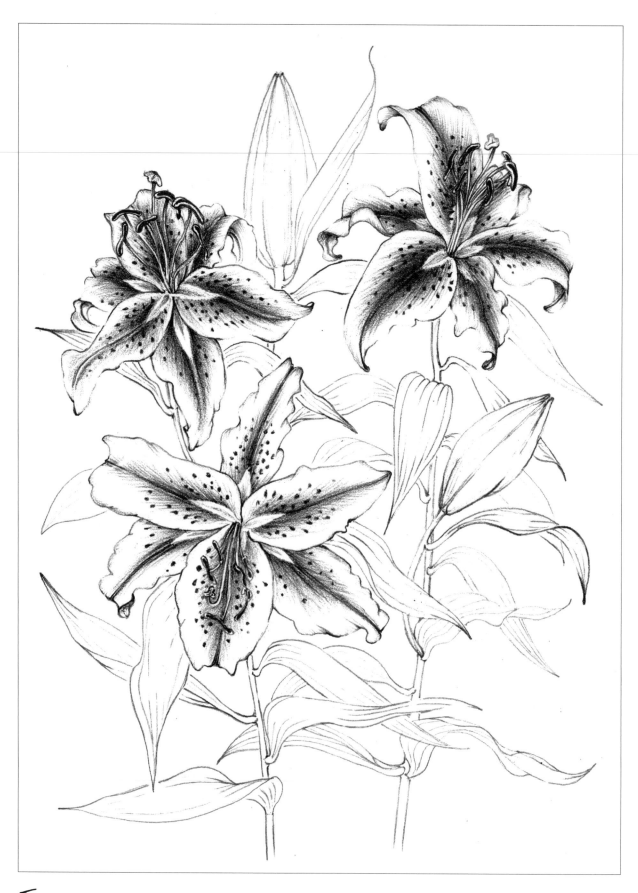

5 Draw in the shapes of the buds, stalks and leaves with HB pencil, making sure that parts of the straight lines of the stalks are covered by several of the leaves.

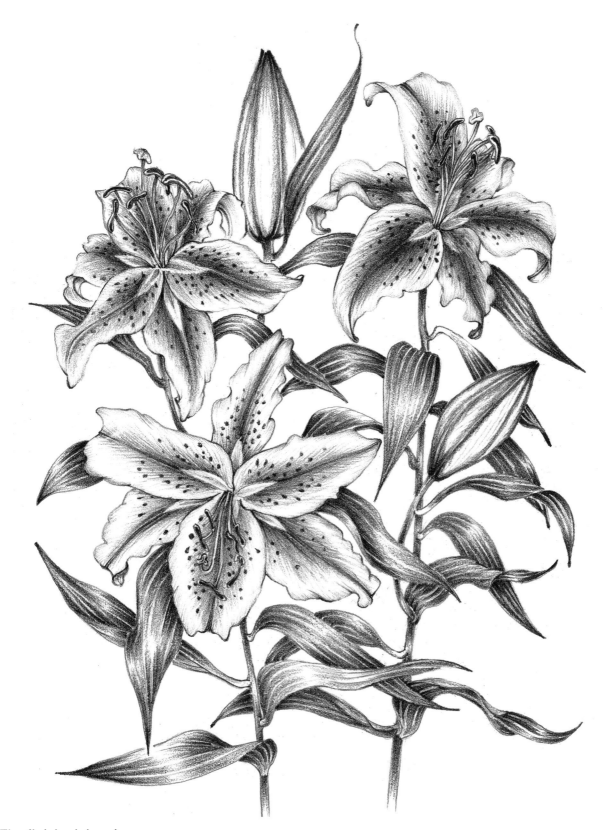

The finished drawing

At the final stage, shade the buds, stalks and leaves. Draw the sharpened pencil away from the points with a firm, curved line, following the shape of the veins, but not covering them, becoming fainter nearer the centre of the leaf to create the impression of shiny leaves. Make the shading darker where the leaves go behind other leaves and flowers and where the leaves curl round away from the light.

Sunflowers

I love sunflowers. The flowers are so radiantly cheerful and the leaves have such definite, curved shapes; they are a delight to draw. If you can persuade your florist to leave the leaves on for you, they make endlessly interesting positive and negative shapes as they curl round and cross over each other. I decided to draw these in acrylic ink with a dip pen, spreading it out with a water pen to provide the shading. Acrylic ink is completely waterproof when dry, and dries fast, so you need to use the water pen quickly while it is still moist. Before I began the main drawing, on A3 watercolour paper, I used a small sketchbook to practise.

MATERIALS

A3, 300gsm (140lb) Hot Pressed watercolour paper

HB pencil

Dip pen with rigid nib

Sepia acrylic ink

Water pen

Jar of water

Paper tissue

I drew these sunflowers on A3 paper but had a little practice in a small A5 cartridge pad (shown here) first to familiarise myself with the ink and water pen technique.

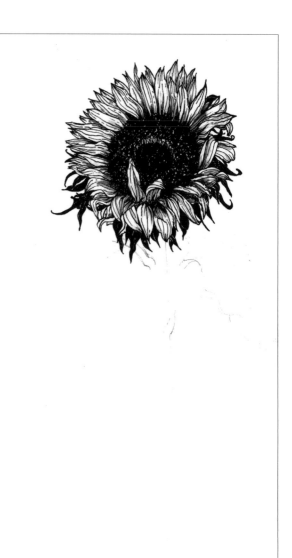

1 Draw an oval in HB pencil for the central disc of the sunflower. Use sepia acrylic ink with a rigid dip pen to draw the lower petals first, starting at the base of each petal. Use the water pen to spread the ink, taking care to leave some white paper alongside each petal. Work round the flower in this way, looking mainly at the flower and drawing each petal in turn. Fill in the central, dark area with many small, curved individual marks, applying the water pen with a slight stabbing motion before each group dries, leaving a few random white spots to add sparkle. Rinse the water pen occasionally in a jar of water to clean off excess ink. Draw the sepals behind the petals and wet them quickly to make them darker than the petals.

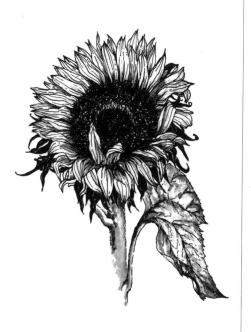

2 Draw the stalk in HB pencil, going over the top part of it with ink when you are satisfied with its position. Draw the large leaf on the right, varying the intensity of the shading with the water pen, and the stalk of the top leaf on the left.

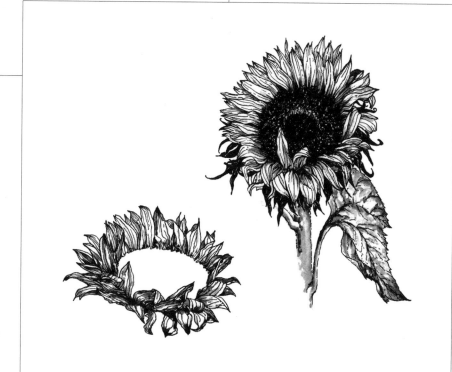

3 Position the centre of the lower sunflower in pencil and draw the petals, carefully noting the shape and alignment of each petal and wetting them in groups of two or three before the ink dries. Draw in the rim of the central disc with a broken edge.

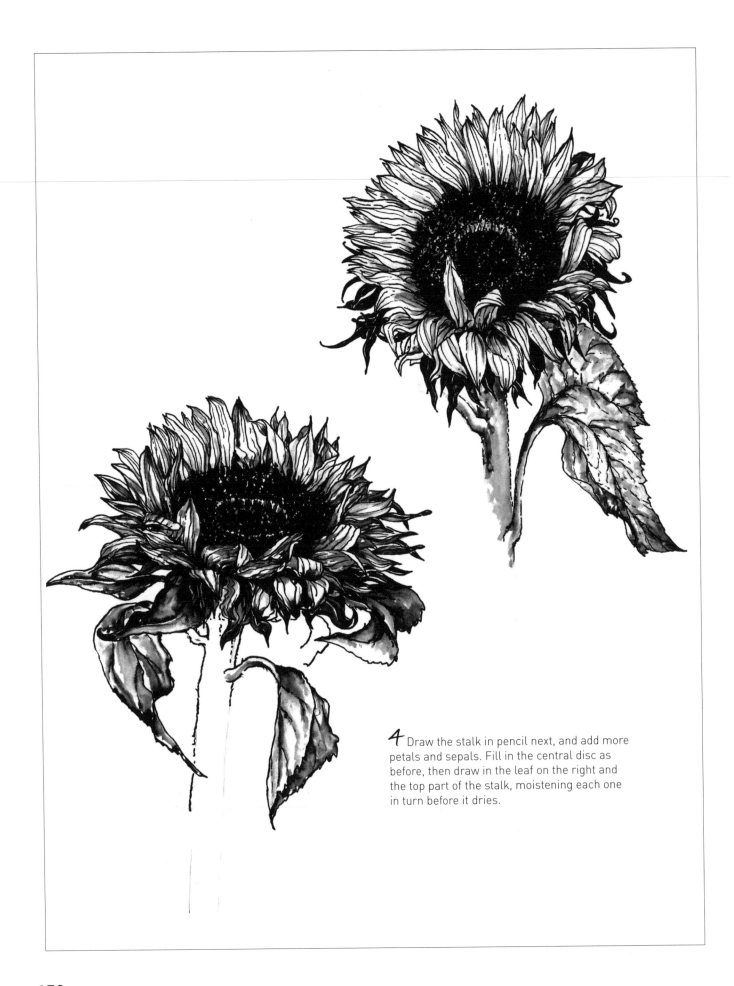

4 Draw the stalk in pencil next, and add more petals and sepals. Fill in the central disc as before, then draw in the leaf on the right and the top part of the stalk, moistening each one in turn before it dries.

The finished drawing

Complete the picture by drawing in more longer, waving sepals, then the leaves and stalks of both sunflowers. Do the foremost ones first, followed by those behind. Vary the tone of the shading with the water pen to give a three-dimensional effect, adding more acrylic ink as necessary or blotting with tissue. Notice the texture and small hairs of the stalks.

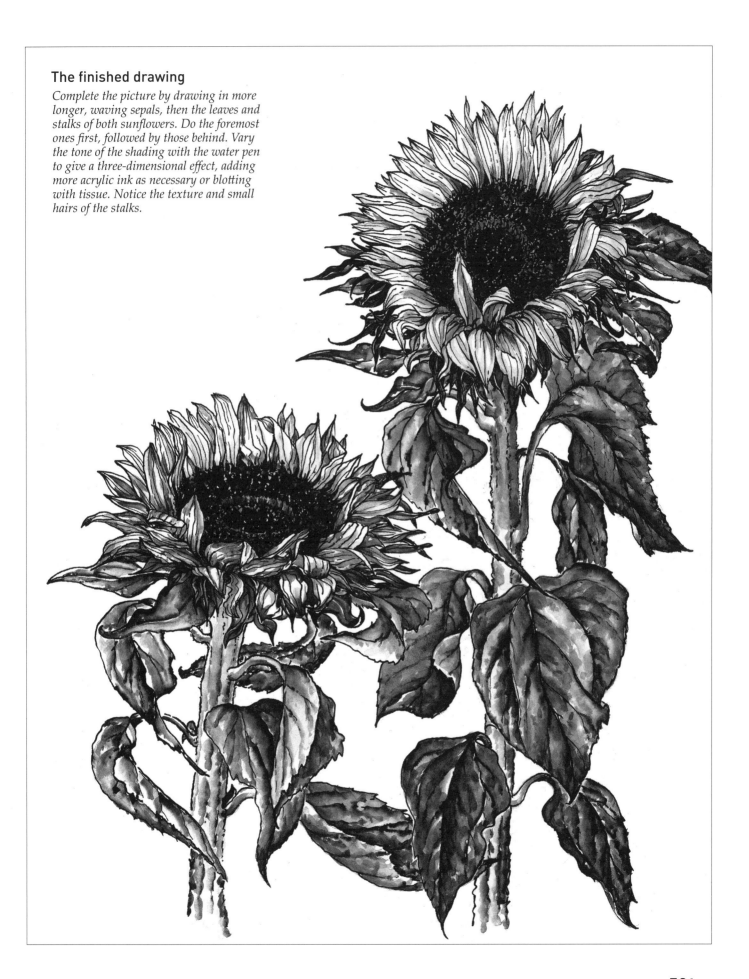

MIXED FLOWER STUDIES

Many flowers are enhanced by being placed in an arrangement with other complementary species, as most florists will agree. Different shapes and sizes harmonise together like a symphony and make a pleasing picture. Sometimes the flowers have already been placed together, as in the French Window Box drawing below; sometimes they are growing together, as in a field of wild flowers, and sometimes I can enjoy deciding which flowers will go together well.

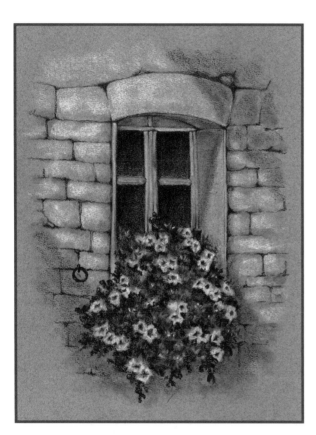

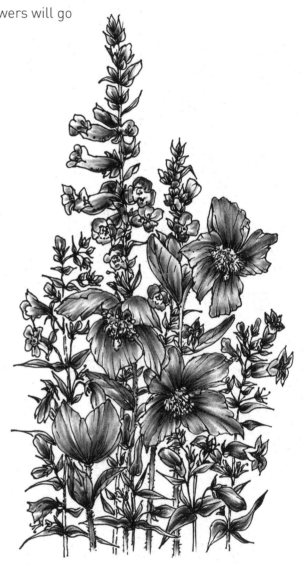

French Window Box

I first saw this window box, overflowing with flowers, when I was teaching at a painting holiday in Mayenne, so I took a photograph. The pastel paper provides the medium tones behind the white texture of the stones, and makes the window and petunias stand out. The sepia Conté crayon is perfect for the contrasting dark leaves and crevices between the stones. I think the ring in the wall was where the locals tied up their donkey!

Meconopsis and Penstemon

Artist's sketching pen (alcohol-based permanent ink) and pastel on watercolour paper. I used a photograph for the meconopsis (blue poppies) as they wilt very quickly. The poppy flowers were drawn straight away in ink with the stalks pencilled in. The penstemon, which grow in my garden, were drawn in ink, behind the poppies and in the spaces. After that I inked in the poppy stalks when I was satisfied that they were in the right place. Finally I added the tones with pastel.

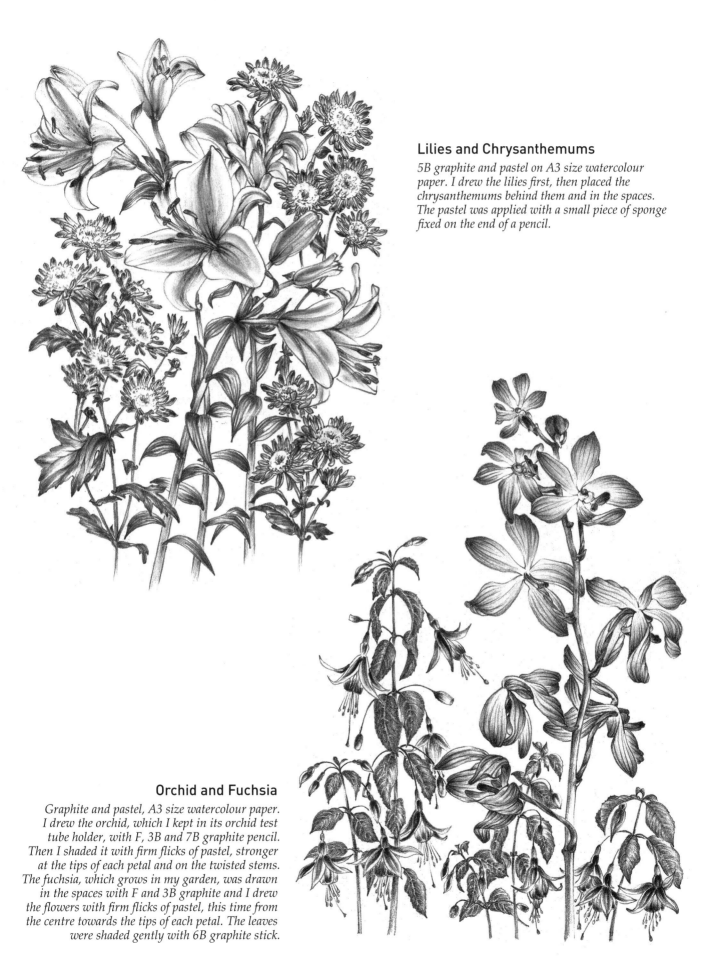

Lilies and Chrysanthemums

5B graphite and pastel on A3 size watercolour paper. I drew the lilies first, then placed the chrysanthemums behind them and in the spaces. The pastel was applied with a small piece of sponge fixed on the end of a pencil.

Orchid and Fuchsia

Graphite and pastel, A3 size watercolour paper. I drew the orchid, which I kept in its orchid test tube holder, with F, 3B and 7B graphite pencil. Then I shaded it with firm flicks of pastel, stronger at the tips of each petal and on the twisted stems. The fuchsia, which grows in my garden, was drawn in the spaces with F and 3B graphite and I drew the flowers with firm flicks of pastel, this time from the centre towards the tips of each petal. The leaves were shaded gently with 6B graphite stick.

61

Tulips and Clematis

This is a busy drawing, rather like a developed doodle. It is full of life and movement and is great fun to do. I sketched the tulips loosely in pencil first, then, after they had been drawn in ink, I added the clematis in the background. I used fresh tulips, held in my hand, then freshly cut clematis balanced in a dish of water.

MATERIALS

A4, 300gsm (140lb) Hot Pressed watercolour paper
HB graphite pencil
Size 03 and 8 artist's pens

1 I held each tulip in turn in my free hand as I sketched them, looking mainly at the flowers. Sketch in their positions loosely in HB pencil with light flowing lines.

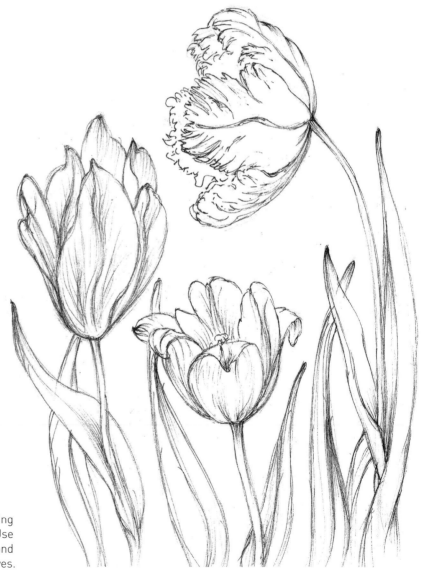

2 With a size 03 artist's pen and loose, flowing movements, sketch the tulip shapes. Use shorter, curved strokes for the flowers and longer strokes for the stalks and tulip leaves.

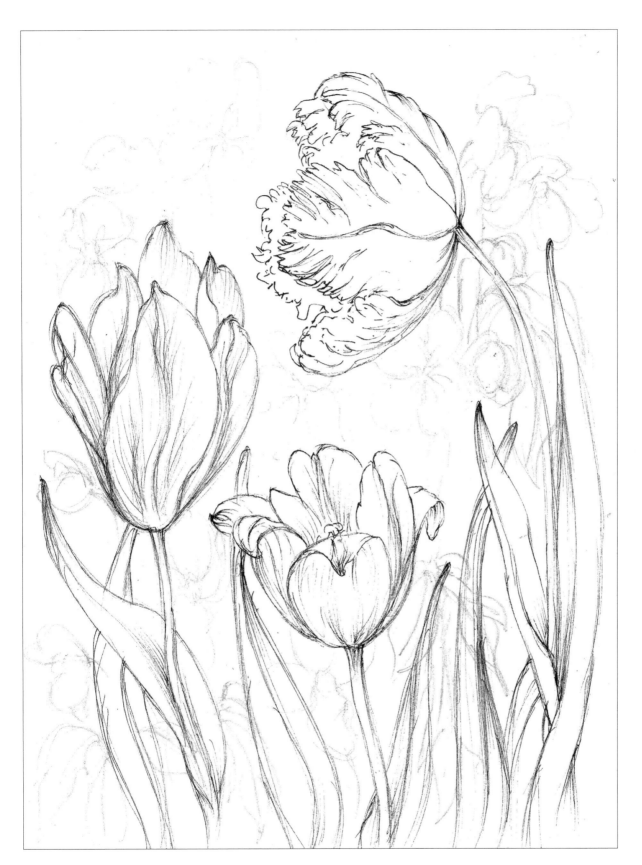

3 Sketch in the clematis behind the tulips with an HB pencil, with quick, curved strokes. Although this stage of the drawing is done quickly, it needs to be done while looking carefully at the flower and concentrating on the shape of each petal or leaf.

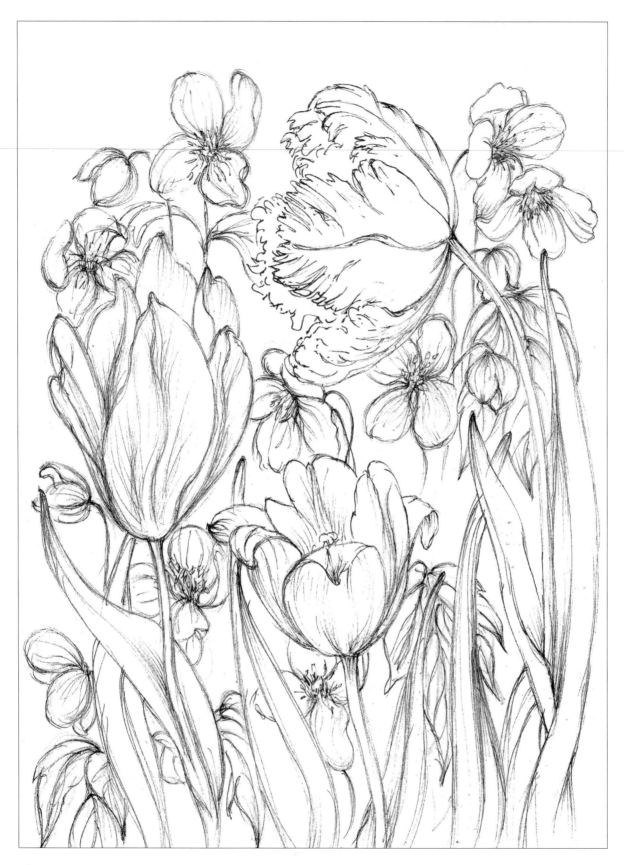

4 With a size 03 artist's pen, confirm the shapes of the clematis flowers and leaves, that have already been placed accurately in pencil. This stage of the drawing has many rounded and curved lines.

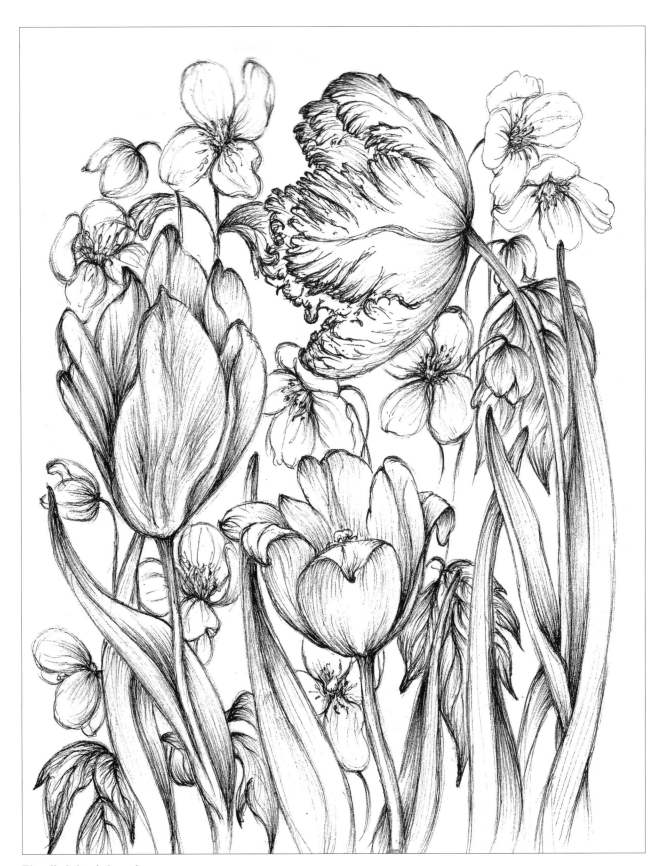

The finished drawing

At the final stage, strengthen the shading on the tulips with a size 08 artist's pen, making the marks stronger in some places by going over them several times as you move round the picture. Slightly strengthen some of the clematis but leave some lines to fade away and disappear behind the tulips.

Strelizia and Dipladenia

The strelizia, or bird of paradise plant, has exotic looking flowers that are wonderful to draw. They are indigenous to South Africa but I think they go very well with dipladenia, a climbing plant with many large flowers, from South America. I started this drawing with live plants in my studio but had to complete it with the help of two photographs.

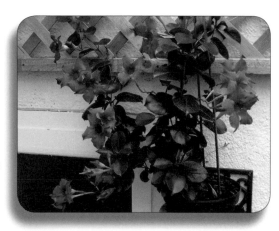

MATERIALS

A3, 300gsm (140lb) Hot Pressed watercolour paper
HB and 9B graphite pencils
5B, 8B, 2B, 4B and 6B graphite sticks

My reference photograph for the dipladenia.

My reference photograph for the strelizia.

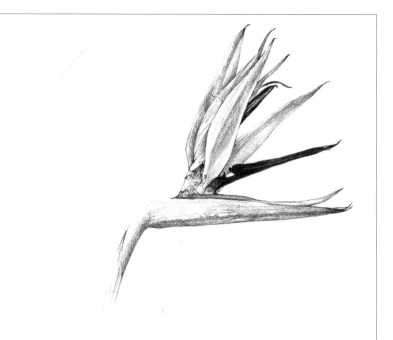

1 With an HB graphite pencil, draw the shape of the strelizia flower in the top right-hand quarter of the page, leaving space for the large leaf to fill the left-hand half of the page. Shade the flower with 5B and 8B graphite sticks and a 9B graphite pencil for the darkest tones.

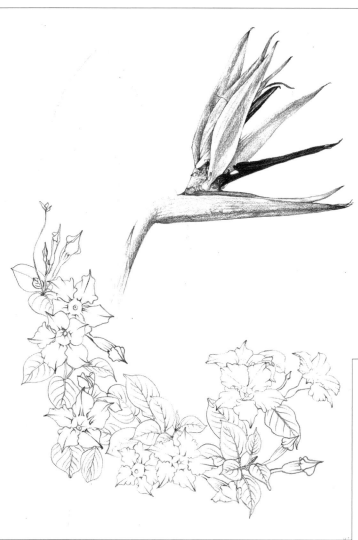

2 Draw the outline of the dipladenia flowers and leaves with HB pencil. At this stage, I looked mainly at the flowers as I drew, and rearranged them slightly.

3 Shade the leaves with an 8B graphite stick, following the shape of the curved veins but not covering them. Make the shading darker at the edge of each leaf and also where they were overlapped by another leaf or a flower.

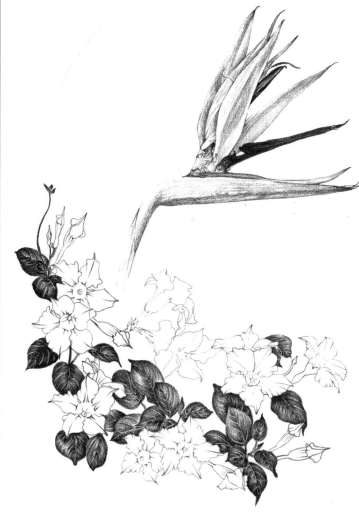

4 Use 2B and 4B graphite sticks to shade the dipladenia flowers, as they are a paler tone than the leaves. Make the petals darker at the edges and around the paler, trumpet-shaped centres.

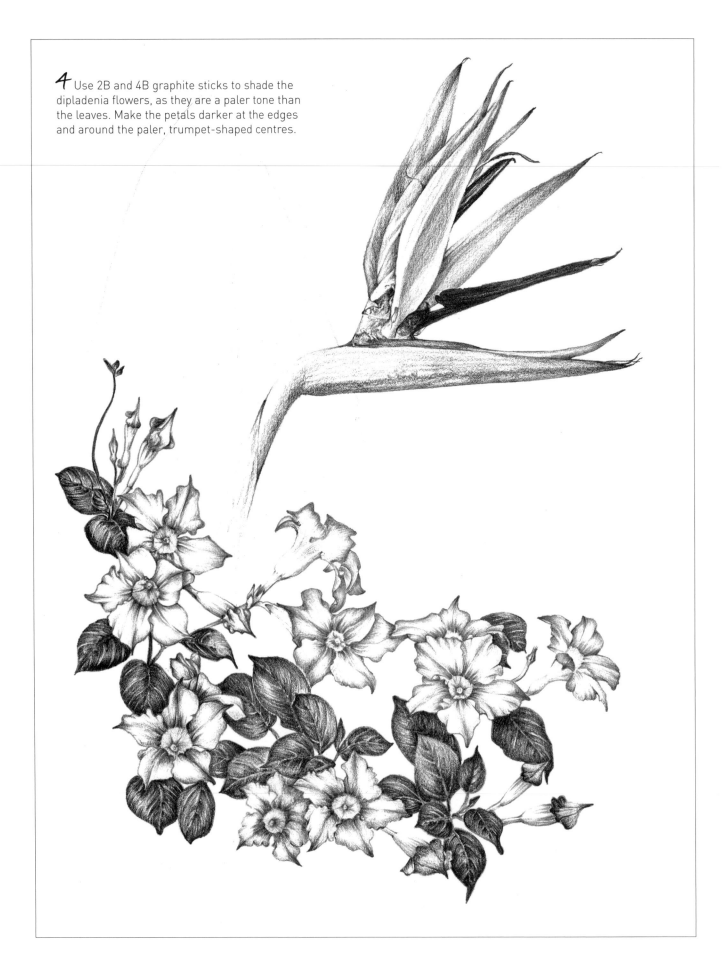

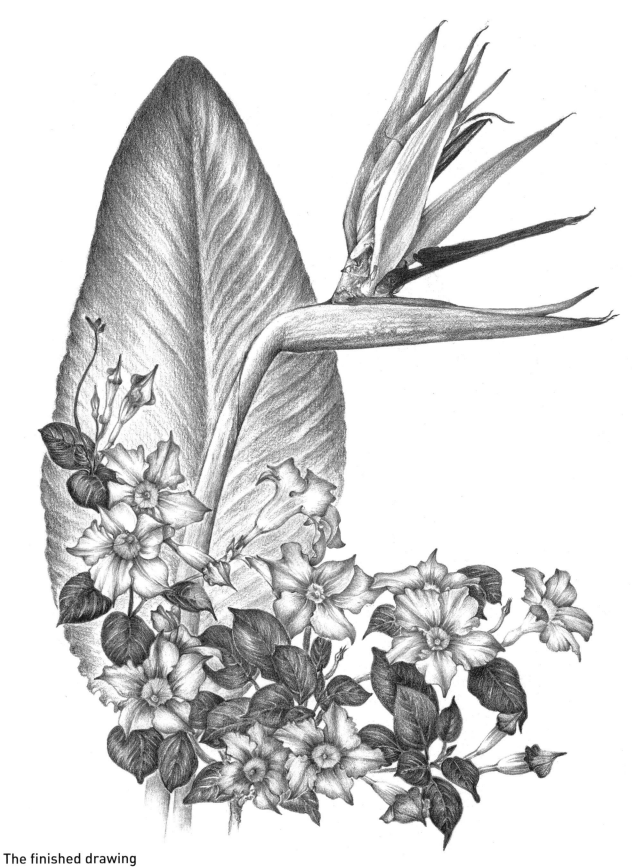

The finished drawing

*Finally, draw in and shade the large strelizia leaf at the back with a 6B
graphite stick, keeping it paler behind the flowers and darker at the edges.
At this final stage, I also added a few extra dipladenia leaves and stalks.*

Passion Flower
and Hibiscus

After I had brought this passion flower home in its pot, I was delighted when it produced a lovely flower. The flowers only last one or two days but there must have been an insect in my conservatory to help pollinate the flower, as later the fruit appeared, which was just right to complete the drawing.

MATERIALS

A3, 300gsm (140lb) Hot Pressed watercolour paper
HB, 8B and 3B graphite pencils
2B and 8B graphite sticks

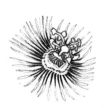

1 With HB pencil, draw the passion flower, strengthening the central parts of the ring of corona filaments with 8B pencil and the ends of the filaments with flicks of 3B pencil.

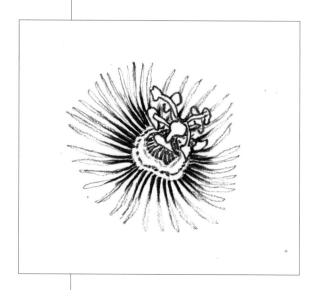

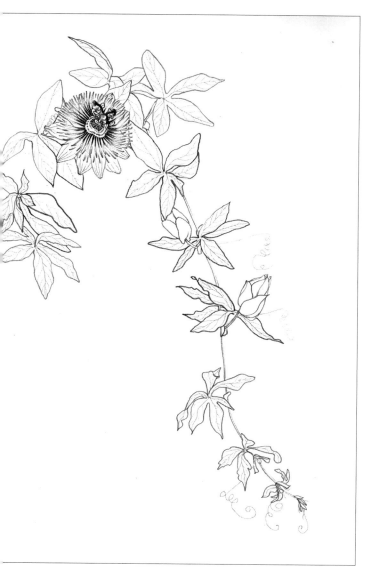

2 Draw the ring of petals and sepals round the edge of the flower and the long trailing stem with the lovely shapes of its leaves, buds and curling feelers.

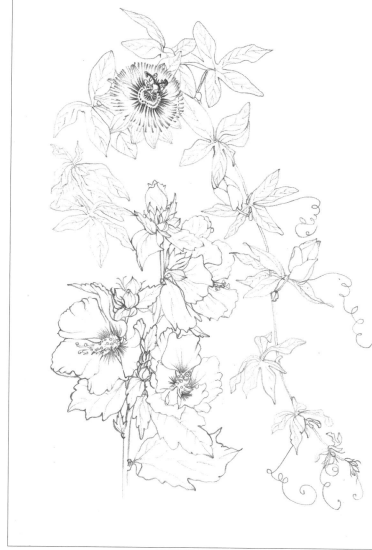

3 I needed to fill the main space on the left of the paper with a different flower. The hibiscus growing in my garden was just the right shape and size, so I cut off a stem and held it in my hand to draw it. Draw the outline of the flowers and leaves in HB pencil, making sure they go behind the leaves on the left and on the right, to link them with the passion flower.

71

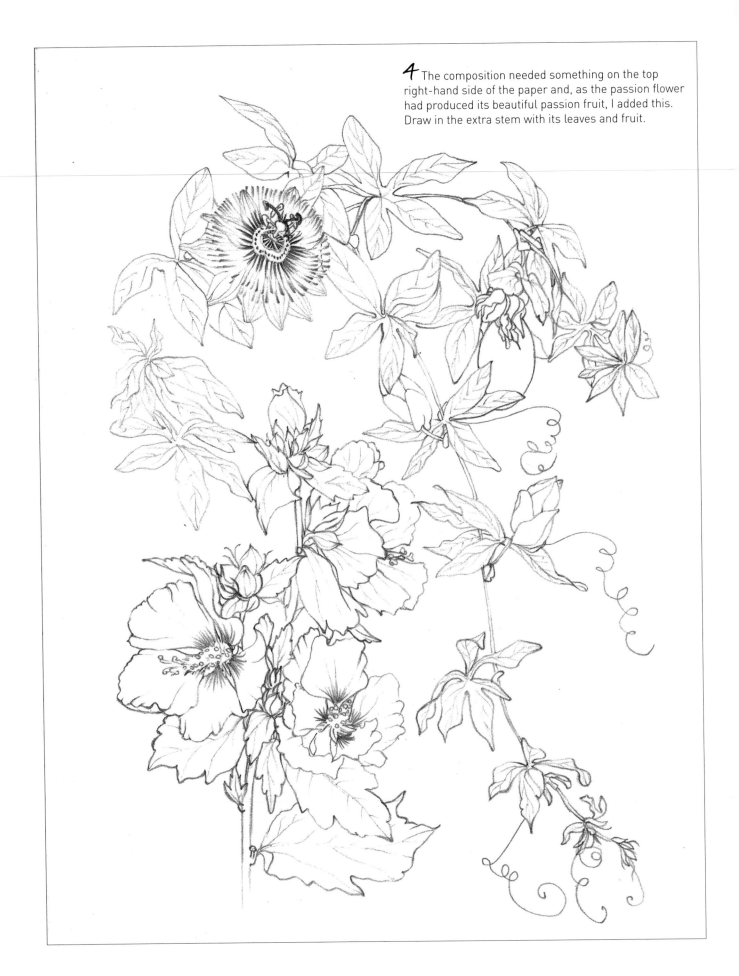

4 The composition needed something on the top right-hand side of the paper and, as the passion flower had produced its beautiful passion fruit, I added this. Draw in the extra stem with its leaves and fruit.

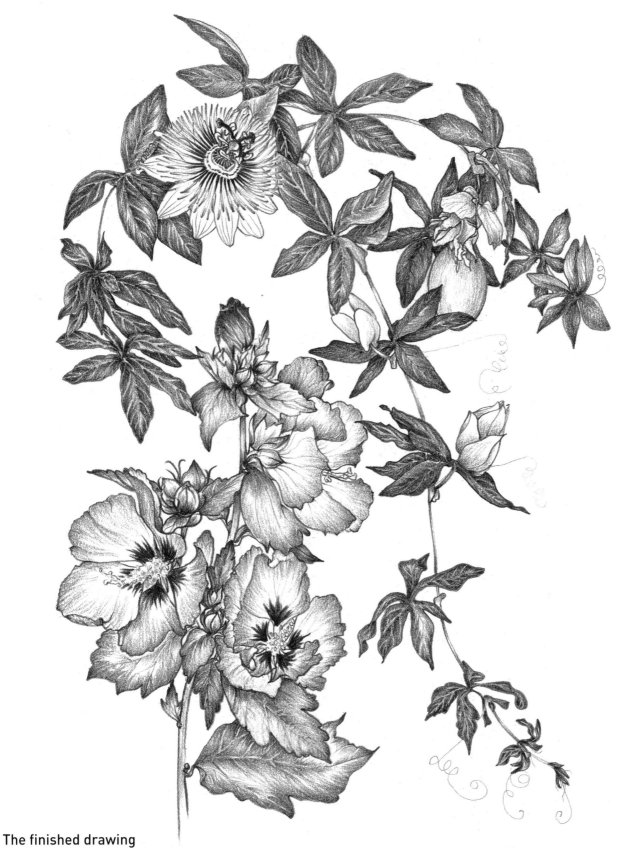

The finished drawing

The final stage is to add the shading. Use gentle, graded strokes of 2B graphite sticks for the paler tones and 8B graphite sticks for the darker tones, leaving the veins on the leaves in paler tones. Where one leaf overlaps another, shade the lower leaf to make it lighter behind the darker leaf tip, and darker behind a paler part of the upper leaf. Use 8B pencil for the strong marks at the base of each hibiscus petal. The darker tonal values of the passion flower leaves offset the paler flowers.

BLOSSOM

A tree in blossom is a wonderful sight and an inspiration to many artists. Drawing blossom has certain difficulties as it is normally in bloom for quite a short time. Any windy day will blow away all the petals and the chance to draw it from life is lost for another year. When a twig of blossom is cut from the tree, it only lasts for a day before wilting. It can help to preserve it longer if you dip the base of the stem in a little boiling water for about thirty seconds before putting it in cold water.

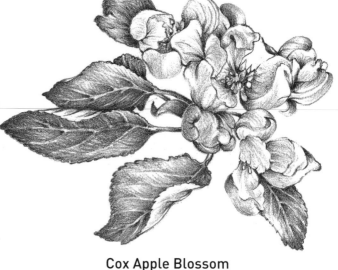

Cox Apple Blossom

This was drawn with graphite pencil in grades HB, 2B and 4B on Hot Pressed watercolour paper. The curling nature of the florets and leaves was a delight to draw. I emphasised the deeper tones of the leaves to contrast with the florets and buds.

Orange Blossom

Drawn in acrylic ink with a dip pen. This was easier to draw as the florets and leaves were more spaced out. I left the florets without shading so that they stood out against the shading on the leaves.

74

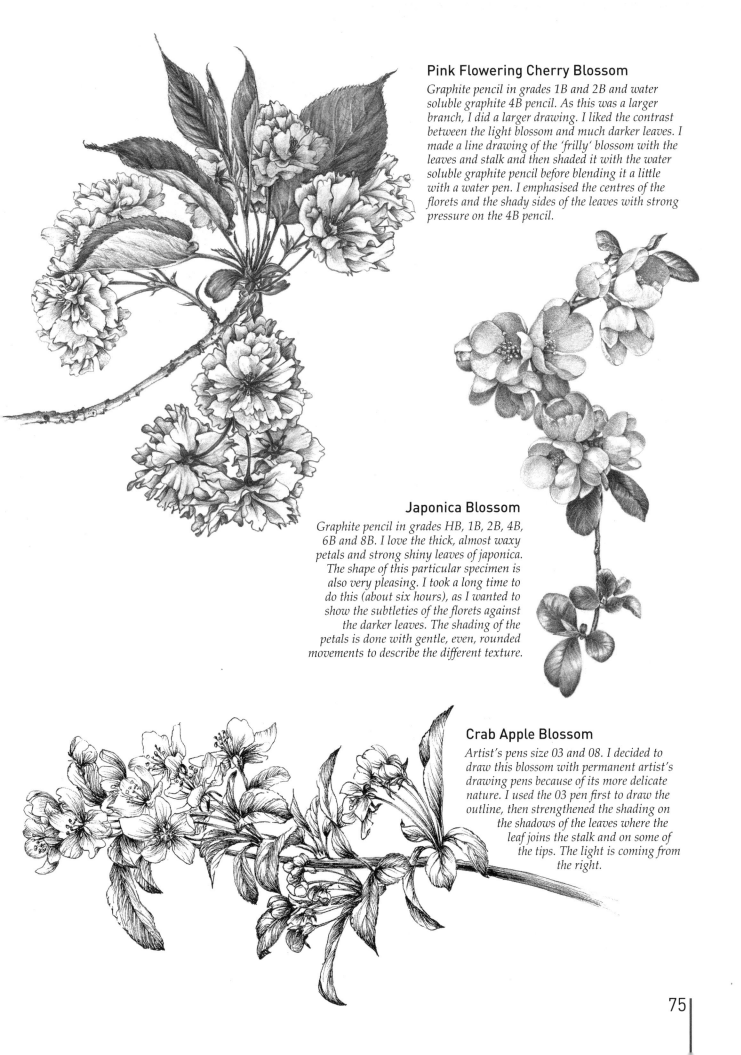

Pink Flowering Cherry Blossom

Graphite pencil in grades 1B and 2B and water soluble graphite 4B pencil. As this was a larger branch, I did a larger drawing. I liked the contrast between the light blossom and much darker leaves. I made a line drawing of the 'frilly' blossom with the leaves and stalk and then shaded it with the water soluble graphite pencil before blending it a little with a water pen. I emphasised the centres of the florets and the shady sides of the leaves with strong pressure on the 4B pencil.

Japonica Blossom

Graphite pencil in grades HB, 1B, 2B, 4B, 6B and 8B. I love the thick, almost waxy petals and strong shiny leaves of japonica. The shape of this particular specimen is also very pleasing. I took a long time to do this (about six hours), as I wanted to show the subtleties of the florets against the darker leaves. The shading of the petals is done with gentle, even, rounded movements to describe the different texture.

Crab Apple Blossom

Artist's pens size 03 and 08. I decided to draw this blossom with permanent artist's drawing pens because of its more delicate nature. I used the 03 pen first to draw the outline, then strengthened the shading on the shadows of the leaves where the leaf joins the stalk and on some of the tips. The light is coming from the right.

75

Apple Blossom

This sprig of apple blossom was so perfect that I had to pick it and sacrifice the apples that might have grown later. It has just three florets open and a few little buds that are surrounded and framed by the darker leaves.

MATERIALS

A4, 300gsm (140lb) Hot Pressed watercolour paper
HB, B, 2B, 3B and 4B graphite pencil

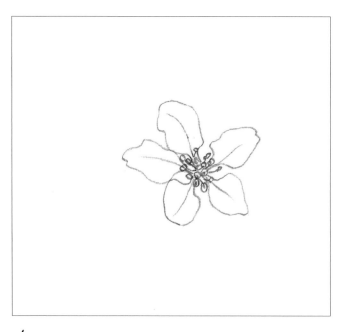

1 With a sharp HB pencil, outline the first floret, noticing that the five petals make five negative shapes as they become very narrow and meet in the centre. Start with the round-ended anthers of the stamens in the centre.

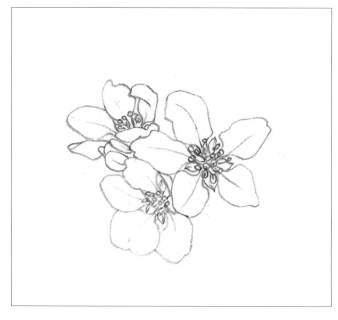

2 With HB pencil, draw the other florets and the large bud, making sure you have five petals for each floret.

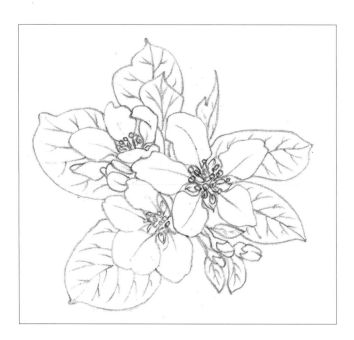

3 Still using HB pencil, draw the shapes of the leaves, noticing the curved shape and the angle of the veins on each leaf. Also draw the group of small buds and leaves at the bottom right-hand corner.

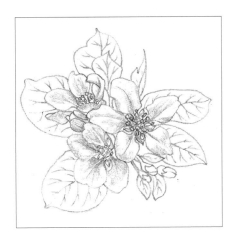 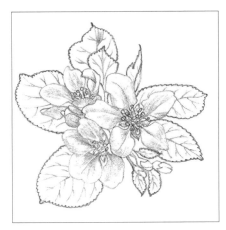 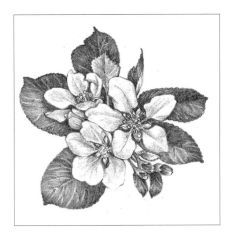

4 With B pencil, very gently shade some faint shadows on the blossom with the pencil barely touching the paper. The light is coming from above, so it will strike each petal in a different way. Where one petal is overlapped by another, there is a gentle shadow on the lower one.

5 With a sharp B pencil, draw the round serrated edges of each leaf, noticing the shape of the serrations, which are curved rather than being zigzagging straight lines.

6 With 2B pencil, add tone and shading to the leaves and the small group of buds. Make the strokes radiate from the edge to the base of each leaf and then from the base at the same angle as the veins. Draw alongside the veins, leaving them a lighter tone. Leave a part of each leaf lighter where the light strikes it. If you have made it too dark, you can gently remove some graphite by dabbing it gently with the point of a putty eraser.

7 Strengthen the shading near the tips and base of each leaf with a 3B pencil. Then strengthen the side of each smaller bud with a 3B or 4B pencil, as they are a deeper tone. You may need to redefine the edge of some petals with a very sharp B pencil, but try to avoid making a strong, even line round each petal, as it is more interesting to create 'lost and found' edges (see page 28).

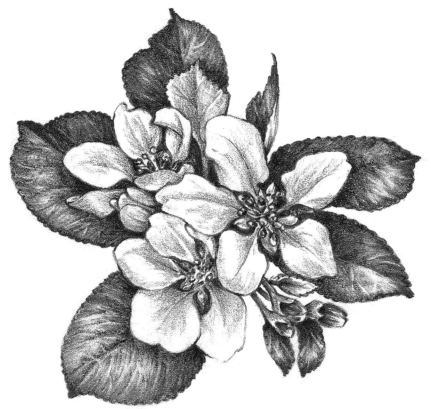

The finished drawing.

DRIED FLOWERS

When flowers die and dry out, they take up interesting shapes and forms that are quite different from the colourful, living flowers they once were. For example, the large hibiscus I have drawn here was a bright, ordinary flower that only lasted a day before it twisted and turned and eventually fell off. The tones also became more varied and, as another bonus, it will last like this indefinitely if treated carefully!

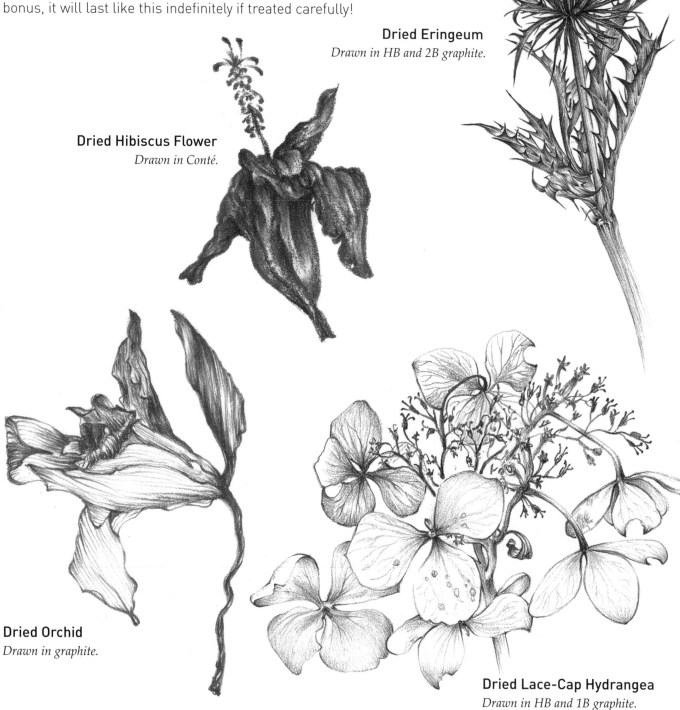

Dried Eringeum
Drawn in HB and 2B graphite.

Dried Hibiscus Flower
Drawn in Conté.

Dried Orchid
Drawn in graphite.

Dried Lace-Cap Hydrangea
Drawn in HB and 1B graphite.

78

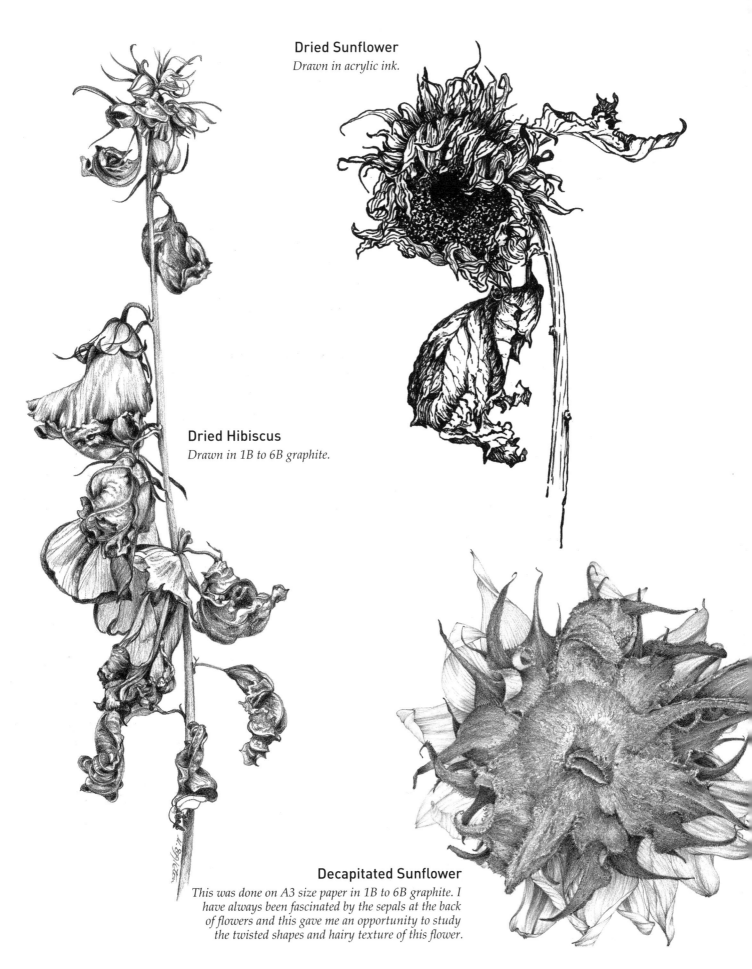

Dried Sunflower
Drawn in acrylic ink.

Dried Hibiscus
Drawn in 1B to 6B graphite.

Decapitated Sunflower

*This was done on A3 size paper in 1B to 6B graphite. I
have always been fascinated by the sepals at the back
of flowers and this gave me an opportunity to study
the twisted shapes and hairy texture of this flower.*

Dried Tulips

These tulips twisted and turned as they dried with such wonderfully subtle colours and variations in tone. They needed to be handled very carefully as they were very fragile. I arranged a lamp with a daylight bulb to shine on them from the right-hand side as I drew them. As pastel and graphite are easily smudged, I was careful to protect the drawing from my hand at all stages, with a piece of transparent acetate.

MATERIALS

A4, 300gsm (140lb) Hot Pressed watercolour paper
Transparent acetate
HB, 3B and 8B graphite pencils
Pastel with narrow sponge and sponge holder

1 Draw the outline of the first tulip in HB graphite pencil, marking in the veins on the petals and leaves and drawing the twists on the stem.

2 Mark in the main tones in pastel, applied with a very narrow sponge on a sponge holder.

3 Using a well sharpened 3B graphite pencil and varying the pressure, define the lines and edges. Emphasise the tones in the shadows with 8B graphite pencil.

4 Draw the outline of the second tulip with HB pencil.

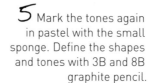

5 Mark the tones again in pastel with the small sponge. Define the shapes and tones with 3B and 8B graphite pencil.

6 At this stage, I felt that the drawing would be better balanced if the second tulip had a leaf on the right, so I detached a leaf from another dried flower to work from. Draw this in with HB pencil.

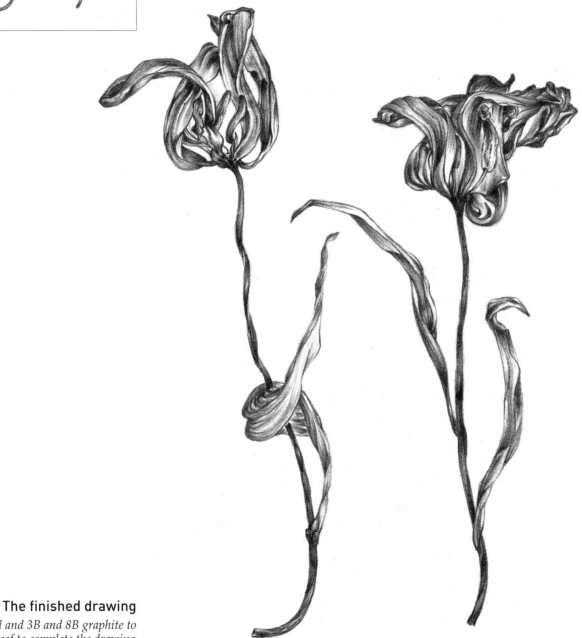

The finished drawing
Apply pastel and 3B and 8B graphite to the final leaf to complete the drawing.

When I draw flowers in containers, I usually draw the flowers first, then draw the container to fit the scale of the flowers, and finally place the stalks and leaves. Alternatively, you can draw the container first to make sure it looks symmetrical before drawing the flowers. Occasionally I trace the container drawing, fold the tracing paper in half exactly down the middle, then make adjustments to the drawing to make sure it is perfectly symmetrical.

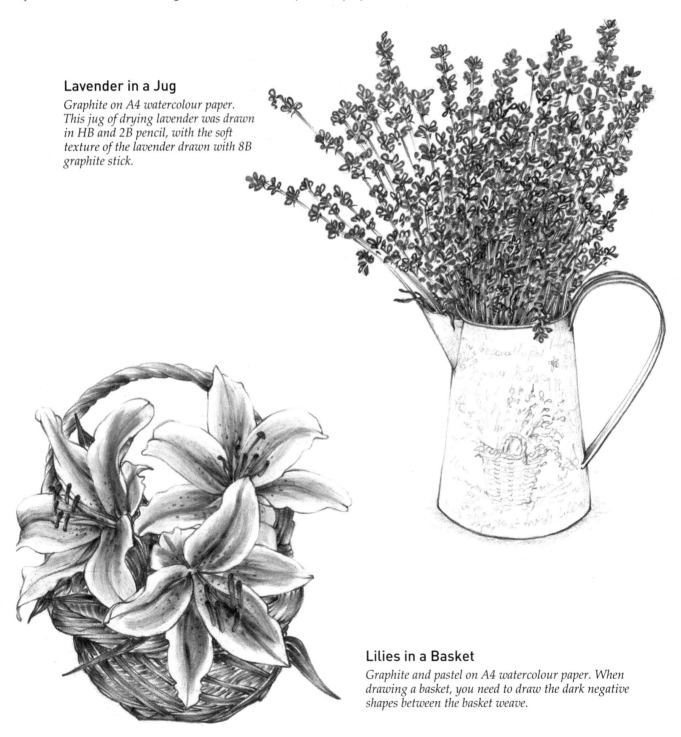

Lavender in a Jug

Graphite on A4 watercolour paper. This jug of drying lavender was drawn in HB and 2B pencil, with the soft texture of the lavender drawn with 8B graphite stick.

Lilies in a Basket

Graphite and pastel on A4 watercolour paper. When drawing a basket, you need to draw the dark negative shapes between the basket weave.

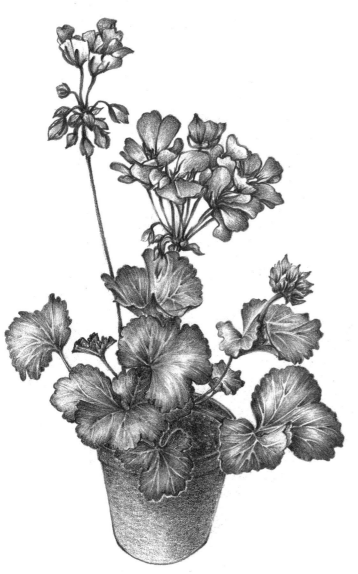

Regal Pelargonium in a Plant Pot

*4B water soluble graphite on A4 Hot Pressed watercolour paper.
When shading the pot and soil, I left a small amount of white
paper behind the leaves to make them stand out.*

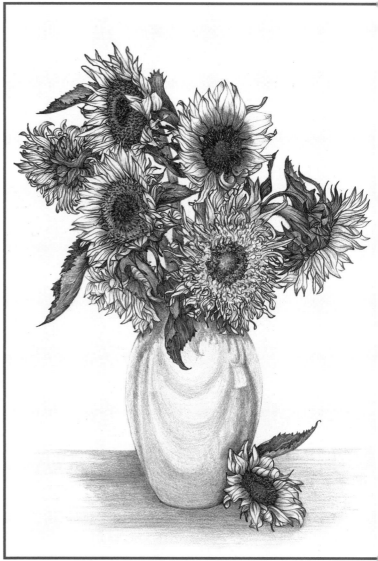

Variegated Sunflowers

*Graphite pencils and sticks on 56 x 37cm (22 x 14½in) pale
cream watercolour paper. I was delighted to find this bunch
of sunflowers with so many different shapes and textures to
draw. They were so big that I had to use my largest vase to put
them in. It was also satisfying to decipher the reflections on
the ceramic vase. Placing a flower on the table next to the vase
gives the drawing more interest in the lower half of the picture,
especially if it is covering the lower ellipse of the vase.*

Glass of Nasturtiums

As soon as I saw it, I loved the shape of this glass candle holder, which is just the right size for the nasturtiums that I have always been very fond of. Most containers are symmetrical and round, so an accurate drawing of the ellipses is vital. A transparent container is a challenge for any artist, whether it is a jam jar, a drinking glass or a vase. A container like this helps to explain the principles behind ellipses.

MATERIALS

A4, 300gsm (140lb) Hot Pressed watercolour paper
HB and 2B graphite pencils
Dip pen
Water soluble ink
Putty eraser
Water pen
White Conté pencil

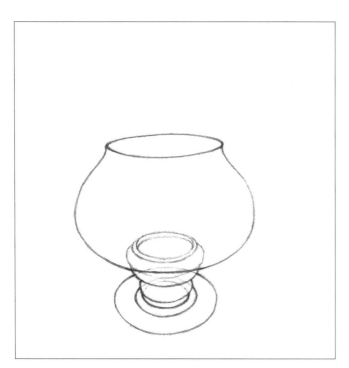

1 First of all, draw the empty glass in HB pencil, to use as a guide. If you hold up any glass, with the top rim at eye level, the rim is a straight line. As you bring the glass lower, the rim becomes a narrow oval shape. The oval or ellipse becomes wider as you bring it lower still, until it is a perfect circle when you look into it from exactly above. This is illustrated here, where I have drawn in some ellipses behind the glass, although they cannot all be seen. This helps to make the curves correct. To draw this yourself, you need to draw each curve with a series of short curved lines, turning the paper round occasionally, observing the shape then looking at the paper, many times. It is very important to make sure the ellipses are not pointed at the sides.

2 With the nasturtiums and water in place and using HB pencil, I started again to draw as much of the glass as I could see, bearing in mind the things I had learnt from drawing it empty. The line of water inside the glass is another ellipse, narrower than the rim and it appears bent where one of the stalks touches the inside of the glass. The water distorts the angles of the ellipses inside the glass as well as the stalks, because the light through the water is refracted. Draw the glass again in this way, then draw the first nasturtium in water soluble ink, making the veins fainter than the edges of the petals. Lightly sketch the other flowers in pencil to make sure the scale of the flowers is right for the glass container.

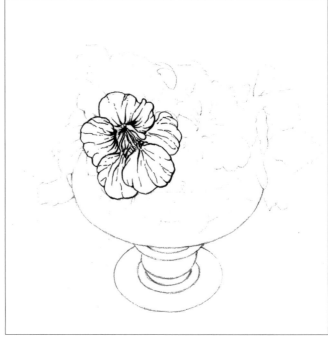

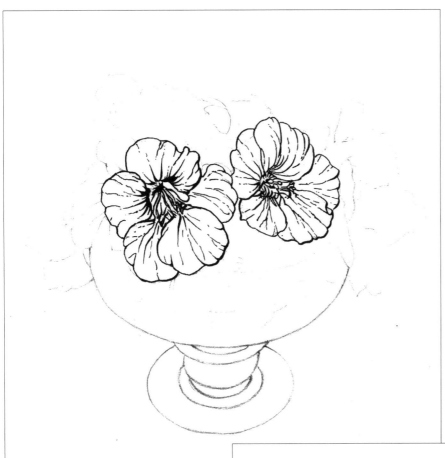

3 Next draw the second flower in water soluble ink using a dip pen.

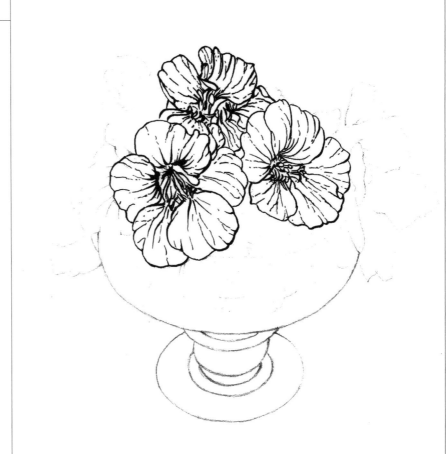

4 The third flower was a darker colour, so draw it with more veins on the petals.

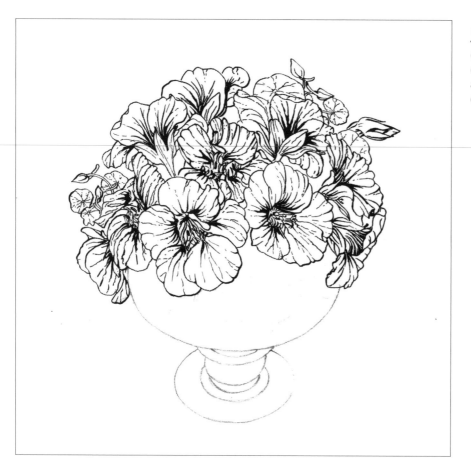

5 Now rub out all the pencil sketches of the flowers. Using water soluble ink, draw in the rest of the flowers, buds and a few small leaves, making the centres darker with stronger lines.

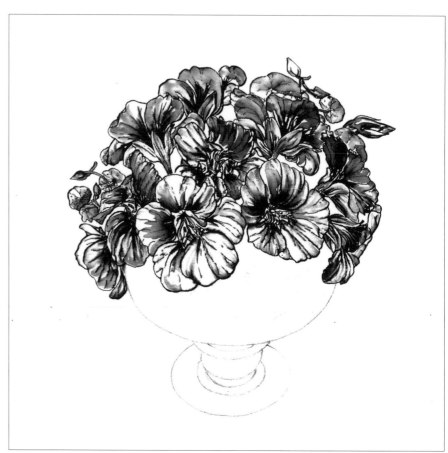

6 With a medium sized water pen, carefully moisten the lines of each petal. Once you have done this, you cannot erase it, so you need to do it accurately and fluently, leaving some white paper showing.

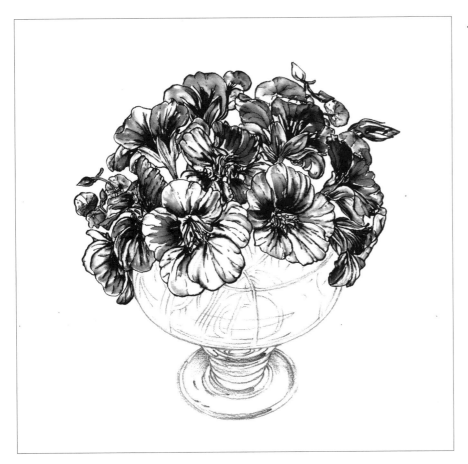

1 Use a 2B graphite pencil to draw the vase, stalks and reflections, so that you will be able to see where they are when you come to add the ink and water.

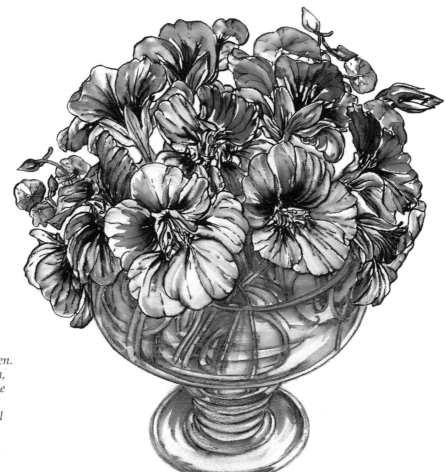

The finished drawing

At the final stage, draw the stalks, vase and waterline in ink and moisten it carefully with a water pen. I thought these lines were too harsh, so I softened most of the lines inside the container and some of those on the outside with white Conté pencil when the ink was dry.

FLOWERS IN THE LANDSCAPE

A landscape is greatly enhanced when it has flowers, which then often become the focal point of the composition. Aerial perspective (where distant things are paler than those in the foreground) and linear perspective (where parallel lines converge at a vanishing point on the horizon and closer objects appear larger) are naturally important, and give the artwork depth and a three-dimensional quality. All this should happen naturally if you draw exactly what you can see.

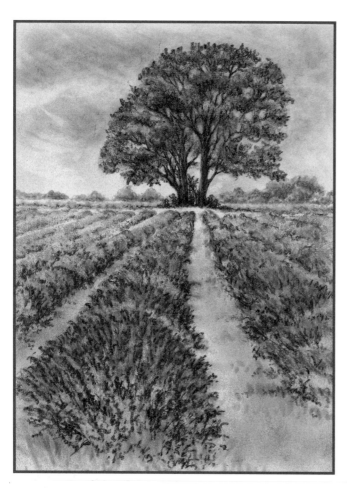

Lavender Landscape

Graphite and Conté on A4 tinted pastel paper. The sight and smell of fields of lavender attract many visitors here during the summer months. This was drawn initially in HB pencil. The details of the copse of sycamore trees and foreground lavender were strengthened with 5B graphite and Conté pencils and crayons. The clouds and the grass between the rows of lavender are graphite dust (obtained when sharpening graphite sticks) applied with a small sponge.

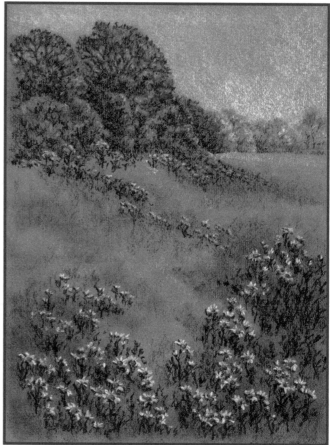

Daisies on the Downs

White Conté pencils and crayons make the daisies stand out against the darker field on the tinted pastel paper. I placed a piece of white Conté crayon on its side for the sky and the lighter parts of the field.

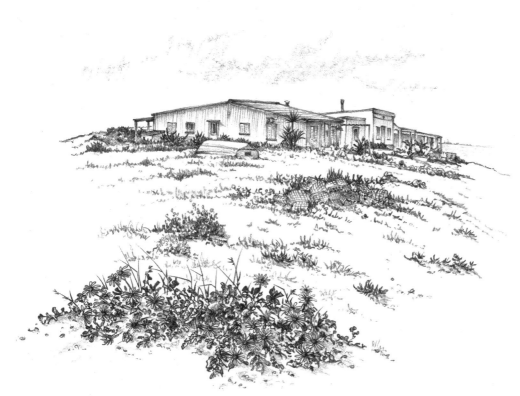

Osteospermum in the Algarve

Graphite on Hot Pressed watercolour paper. I used 5B graphite pencil for most of this drawing, with HB graphite for the foreground flowers and 5B graphite with stronger pressure for the other foreground details. I used a sponge to apply graphite dust for the clouds.

Flowers on the Bridge

Deep indigo coloured water soluble pencil on A4 watercolour paper. I drew the flowers and the banks of this river in France with a well sharpened water soluble coloured pencil. I applied less pressure for the riverside and stronger marks for the flowers that were overflowing their plant container, balanced on the rails of the bridge. A medium water pen was then used delicately to soften the dry lines of the trees and distant chateau, with downward strokes for the reflections in the water. I made the petunias stand out by making the leaves behind them darker and leaving some white paper on the flowers.

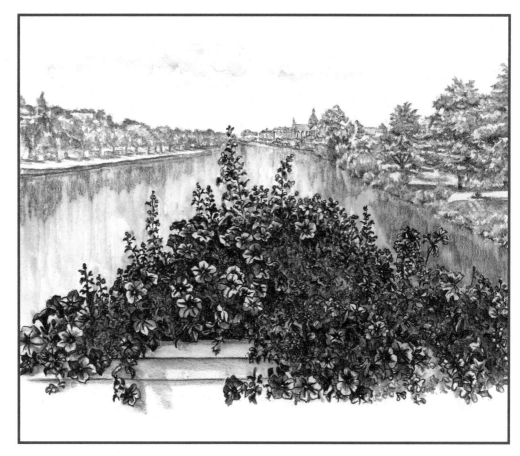

Rhododendron Landscape

Rhododendrons have always been a favourite of mine, with their flamboyant colours and huge, sculptural shapes. Grouped together with azaleas and other flowers that bloom at the same time, they make a breathtaking display.

MATERIALS

A3, 300gsm (140lb) Hot Pressed watercolour paper

F, 4B, 6B, B, 2B and HB graphite pencils

4B and HB graphite sticks

Putty eraser

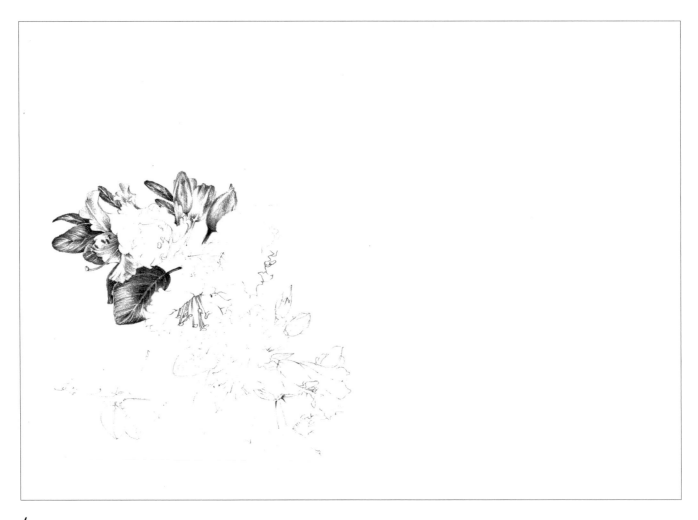

1 Draw the outline of the large rhododendron flowers, leaves and branches lightly with F graphite pencil.

2 Shade the leaves with strong pressure flicks of 4B and 6B graphite pencils, following the curve between the veins, stronger at the edges and either side of the central vein, but leaving some lost and found edges on the lighter left-hand sides. Shade the branches and twigs with 6B pencil in short, almost vertical pressure flicks. Shade the buds with strong pressure flicks at the base and the points.

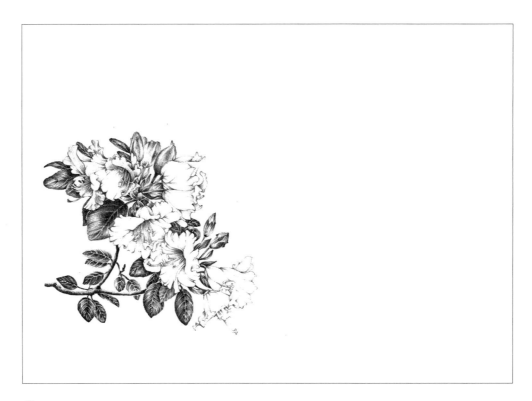

3 Shade the flowers next in B graphite pencil to keep them pale and contrasting with the strong leaves. Keep sharpening the pencil to make very fine lines at the edges of the petals and allow it to get slightly blunt for the gentle shading, making it stronger with 2B pencil behind the stamens and anthers as they go into the centre.

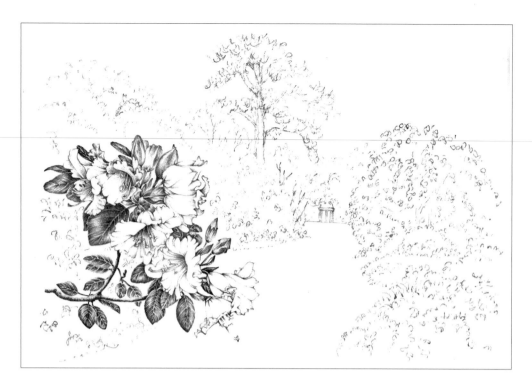

4 Using a B pencil and 4B graphite stick, loosely sketch in the trees, rhododendron and azalea bushes. Carefully and gently draw the little folly building that acts as a distant focal point. All this can be revised as the drawing progresses.

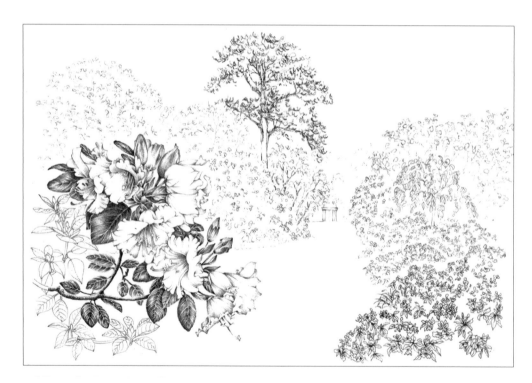

5 Starting with the nearest bushes on the right hand side, use 2B and 4B pencils to make more detailed flower and leaf shapes, making them smaller and fainter with a B pencil as they go into the distance. If any foliage becomes darker than you intend, blot it gently with a small piece of putty eraser. Be careful to leave some white paper between each group of bushes. Make sure the distant trees and bushes are much fainter than the closer ones. Work on the left with the large Cedar of Lebanon tree, making it darker with 2B pencil. Draw more detail on the left-hand bushes, making them larger as they came nearer. At this stage, I decided that the drawing needed some more leaves behind the large rhododendrons instead of the smaller bushes. Sketch these in with B pencil. This was a 'pentimento' – an artistic second thought!

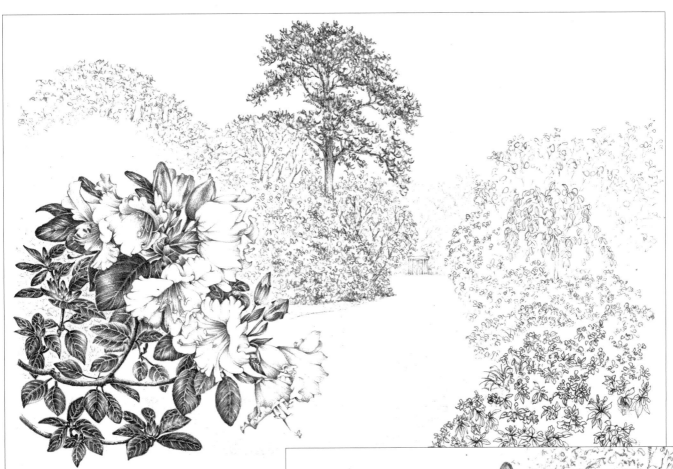

6 Shade the large leaves as before with 4B and 6B pencils and draw more detailed flowers and leaves on the trees and bushes on the left, making them larger than before (see detail, right). Strengthen the cedar of Lebanon tree with short, curved marks in 2B pencil, to represent the foliage. Give the distant trees more tone with HB graphite stick. You can see in these images that I removed some tone from the tree behind the large rhododendron in preparation for a change I made at the final stage (see page 94).

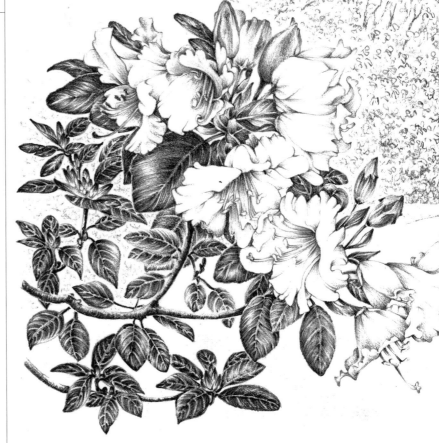

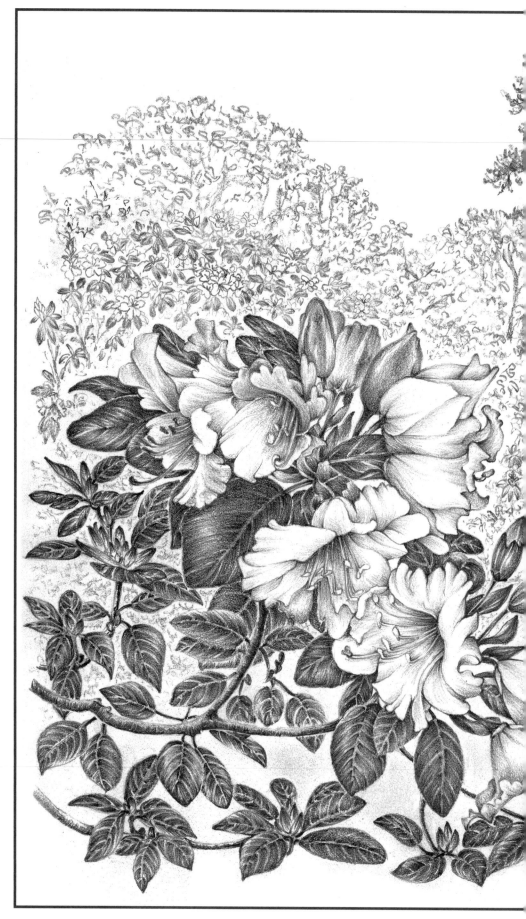

The finished drawing

At the final stage, I realised that the tree behind the large rhododendron needed larger leaves and flowers, so I drew these with 4B pencil, making them fade more before reaching the large flowers and leaves.

Give the leaves of all the bushes on the right more tone and accents with 4B graphite stick in the middle distance and 6B pencil for the nearest bushes on the right, as these need to be darker to balance the tone of the dark leaves on the left. At this stage I realised that the leaves of the large rhododendron needed to be brought further to the right so that they lead the viewer's eye into the landscape. This was another 'pentimento'! Shade the central grass area softly with an HB pencil on its side, then rub it in with your finger.

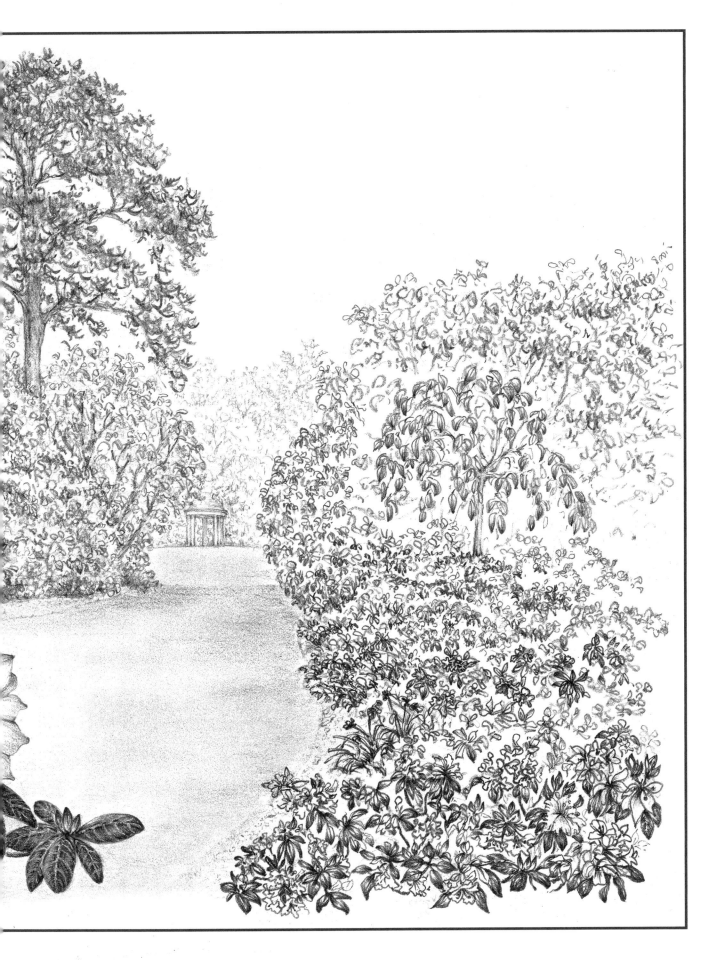

Index

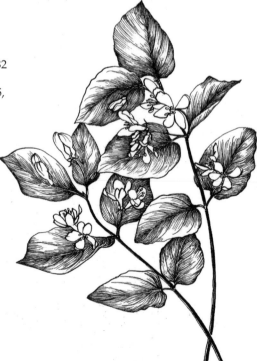